BARNSTAPLE

HISTORY TOUR

First published 2021

Amberley Publishing
The Hill, Stroud,
Gloucestershire, GL5 4EP
www.amberley-books.com

Copyright © Denise Holton &
Elizabeth J. Hammett, 2021
Map contains Ordnance Survey data
© Crown copyright and database
right [2020]

The rights of Denise Holton &
Elizabeth J. Hammett to be identified as
the Authors of this work have been
asserted in accordance with the
Copyrights, Designs and Patents
Act 1988.

ISBN 978 1 3981 0135 7 (print)
ISBN 978 1 3981 0136 4 (ebook)

British Library Cataloguing in
Publication Data.
A catalogue record for this book is
available from the British Library.

Origination by Amberley Publishing.
Printed in Great Britain.

INTRODUCTION

By 930, the date that Barnstaple traditionally claimed to have received its first charter, the basic layout of the town was already in place. Boutport Street and the High Street were in existence with a strong defensive wall surrounding the town.

Barnstaple was one of four 'Burhs' and as such was allowed to mint coins. The earliest known coin made here dates back to King Eadwig's reign (955–59). The town was also important as a centre of commerce. Its old name 'Bearde Staple' means the Market or Staple of Bearda. According to tradition, King Athelstan granted the town a charter with rights to hold markets and a fair.

By 1066 Barnstaple was a well-established town, and twenty years later was mentioned in the Domesday Book where it states 'The King has a Borough called Barnstaple which King Edward held T.R.E. There the King has 40 burgesses within the borough and nine without and they pay 40 shillings by weight to the King and 20 shillings by tale to the Bishop of Coutances. There also 23 houses have been laid in ruins since King William has had England.'

The King held the Borough of Barnstaple for himself and it was not until Henry I came to the throne that the first Lord of Barnstaple, Judhael of Totnes, was created. It was Judhael who in 1107 founded the priory of St Mary Magdalene outside the town wall.

By 1290 Barnstaple had grown further to become an important trading centre, in particular for wool and woollen material (a sturdy woven cloth known as Barnstaple baise) and five years later sent two burgesses to represent the town in Parliament.

The late sixteenth and early seventeenth centuries were the most exciting period in Barnstaple's development. The Great Quay was built at this time, making it easier for ships to load and unload goods, leading to a great increase in trade. Tobacco was imported from the New World and pottery, tools, cloth and other

goods were exported in return. In 1603, work began on the building of a new quay to cope with the expanding trade.

In 1642 the Civil War began. Barnstaple was first held by the Parliamentarians but changed hands four times before the end of the war. It was in June 1645 that Prince Charles (the future Charles II), on the run from the plague in Bristol, took refuge in the town before moving on in July. There was great suffering at this time and much of the town regalia was melted down and turned into coins to pay the troops. It is estimated that it took nearly a century before Barnstaple regained much of its wealth.

After the war, Barnstaple settled down to consolidate its position as a port and industrial centre and in the eighteenth century, Queen Anne's Walk was created in its present form as a merchants' exchange. It was paid for by the merchants themselves and their crests are visible along the top of the colonnade. A statue of Queen Anne adorns the top together with a crest celebrating the victory at the Battle of Blenheim in 1704. It shows defeated French soldiers on their knees surrounded by muskets and cannon. Marshy land at the end of the bridge was drained at this time and, in 1710, the first proposals were made to create a formal Square. Several roads leading to Barnstaple were repaired and widened after George III passed an act requiring this work to be carried out.

In 1825 steam was used for the first time in Barnstaple to power lace bobbins at the Derby Mill factory and a year later the present Guildhall was built, replacing the Old Guildhall (actually Barnstaple's second) which stood at the entrance to the churchyard. During the first half of the century, the population had doubled to 8,500 and by 1835, the town's boundaries were extended to include Pilton and Newport. There was much redesigning taking place and in 1854 the Barnstaple to Exeter railway opened to great celebration.

The continuing silting of the River Taw resulted in the running down of Barnstaple as a port, and, as time passed the major part of the woollen industry moved to other parts of the country with other, larger ports taking much of Barnstaple's trade.

However, the twentieth century saw a gradual resurgence of Barnstaple's fortunes with several major firms settling in the town at Pottington and Roundswell and as we move further into a new century Barnstaple continues to flourish as the chief town of North Devon.

KEY

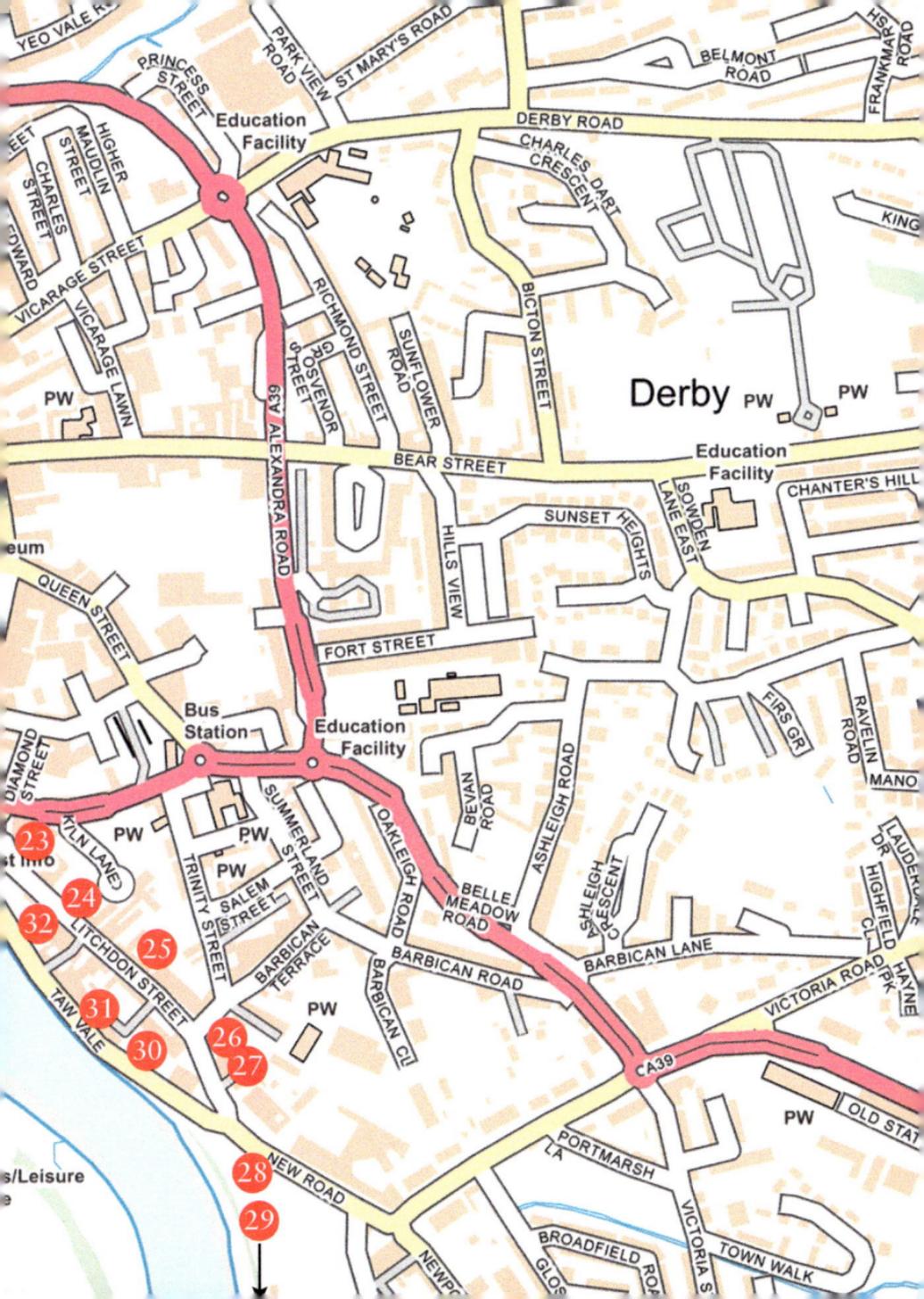

YEO VALE R
PARK VIEW ROAD
ST MARY'S ROAD
BELMONT ROAD
HSI
FRANKMAR
PRINCESS STREET
Education Facility
DERBY ROAD
CHARLES DART CRESCENT
KING
HIGHER MAUDLIN STREET
CHARLES STREET
EDWARD
BICTON STREET
RICHMOND STREET
SUNFLOWER ROAD
VICARAGE STREET
VICARAGE LAWN
GROSVENOR STREET
Derby PW PW
PW
A39 ALEXANDRA ROAD
BEAR STREET
Education Facility
CHANTER'S HILL
eum
QUEEN STREET
HILLS VIEW
SUNSET HEIGHTS
SOWDEN LANE EAST
FORT STREET
FIRS GR
RAVELIN ROAD
MANO
Bus Station
Education Facility
SUMMERLAND STREET
OAKLEIGH ROAD
BEVAN ROAD
ASHLEIGH ROAD
LAUDERVAL DR
DIAMOND STREET
KILN LANE
PW
PW
TRINITY STREET
SALEM STREET
BELLE MEADOW ROAD
ASHLEIGH CRESCENT
HIGHFIELD CL
HAYNE

23

st Info

24

32

LITCHDON STREET

25

BARBICAN TERRACE

BARBICAN ROAD

BARBICAN LANE

VICTORIA ROAD

31

TAW VALE

PW

BARBICAN CL

30

26

27

CA39

OLD STAT

PW

PORTMARSH LA

28

NEW ROAD

s/Leisure

29

VICTORIA S

BROADFIELD RO

GLOS

NEWPC

TOWN WALK

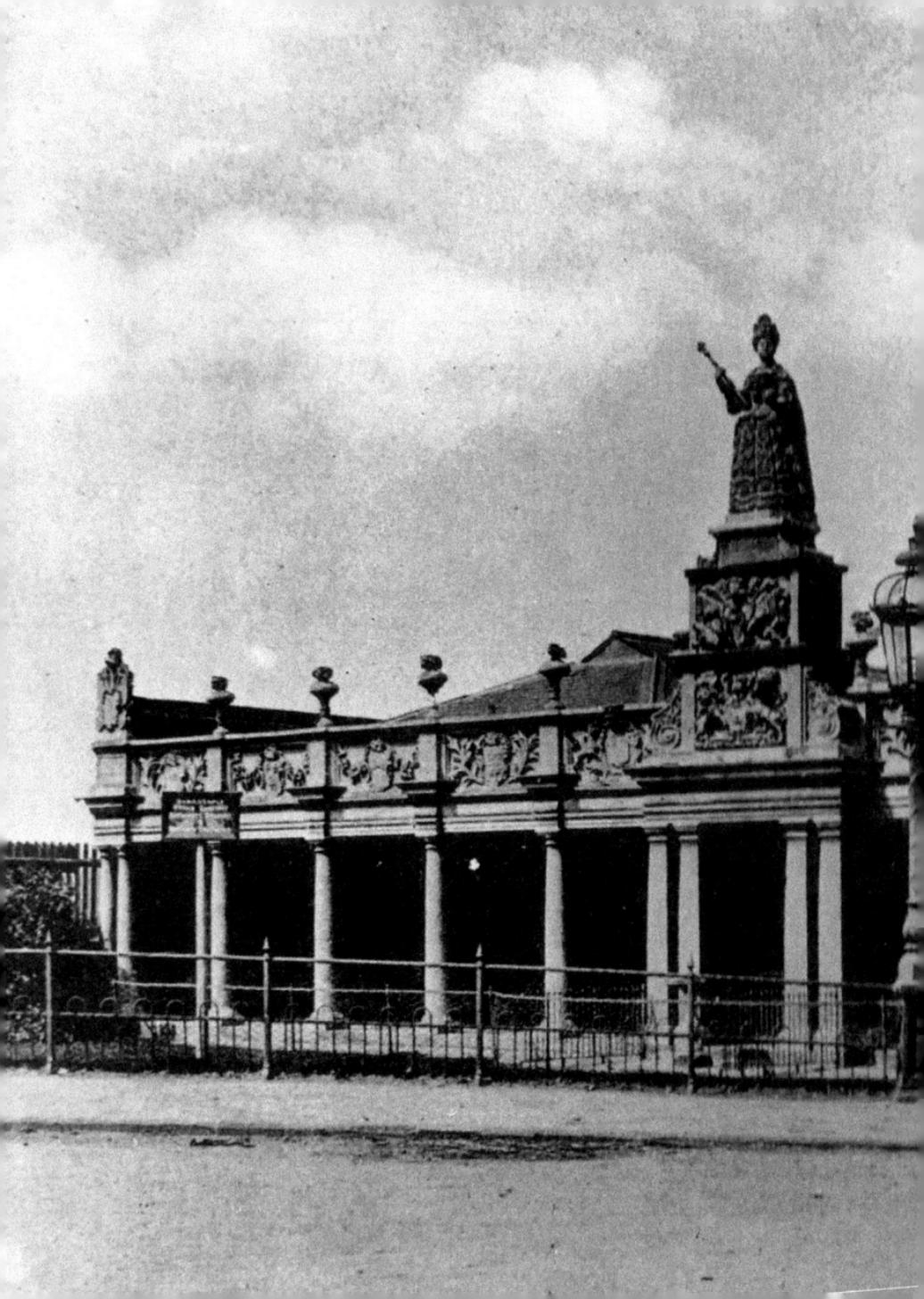

1. QUEEN ANNE'S WALK

Our history tour of Barnstaple begins at Queen Anne's Walk beside the river. The first colonnade – known as The Merchant's Walk – was rebuilt in the early 1700s and renamed Queen Anne's Walk, after the statue was added in honour of the sovereign by Lord Rolle. The tome stone in front of the colonnade, where merchants agreed payment, is dated 1633. In 1859 the building became baths and washhouses, then became the Masonic lodge. More recently it housed the Barnstaple Heritage Centre and is now a café.

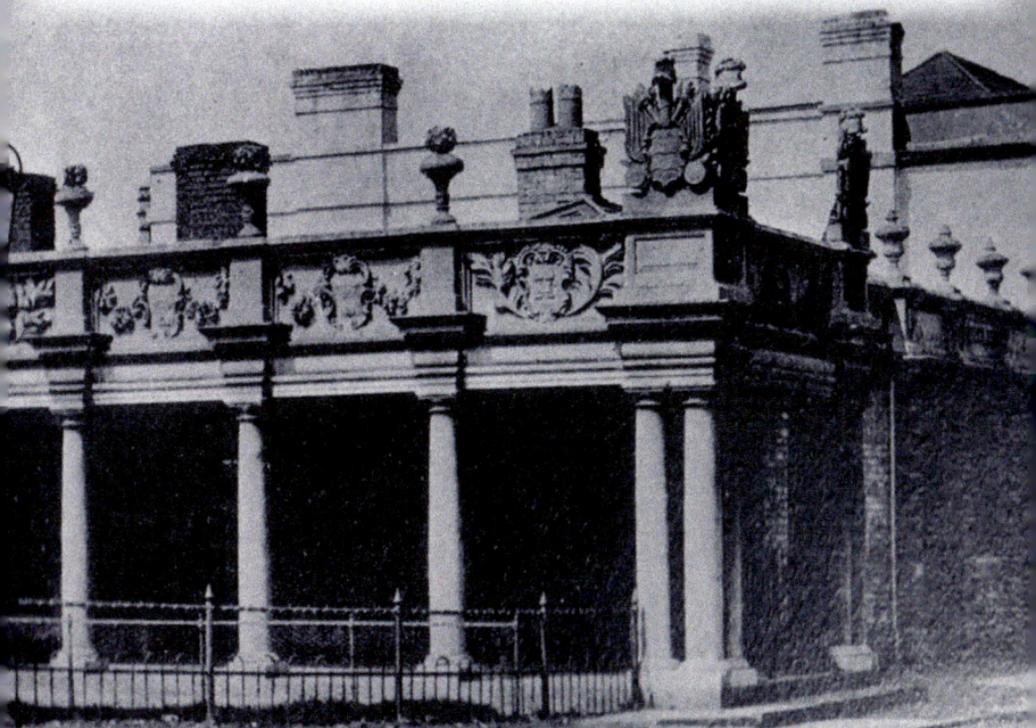

2. MILLENNIUM MOSAIC

The site of the Great Quay, built in the 1550s, is marked by the sunken area in front of the colonnade. For centuries this was an extremely busy area, with ships loading and unloading their goods, pilgrims and soldiers travelling abroad and emigrants journeying to the new colonies. The Millennium Mosaic was laid as part of Barnstaple's millennium celebrations. It is approximately 33 feet in length, running around the edge of the sunken seating area with each panel showing an aspect of the town's history.

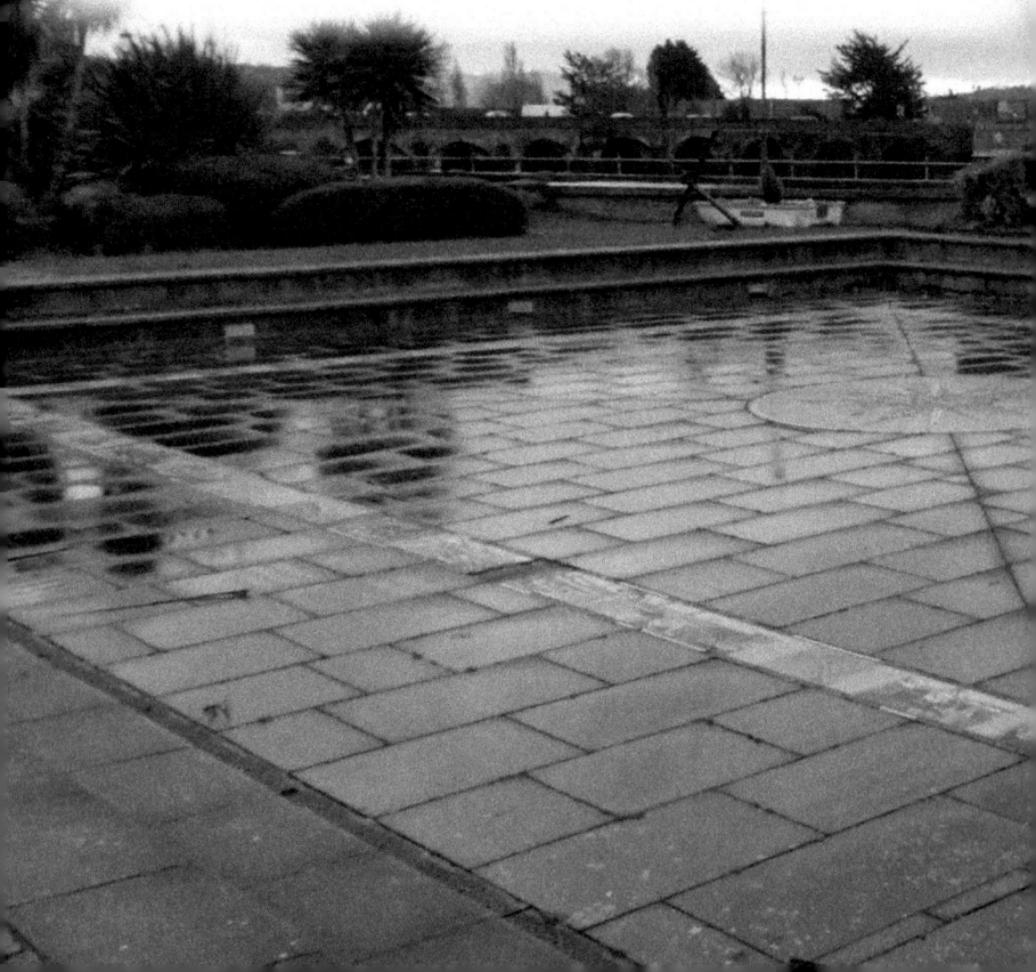

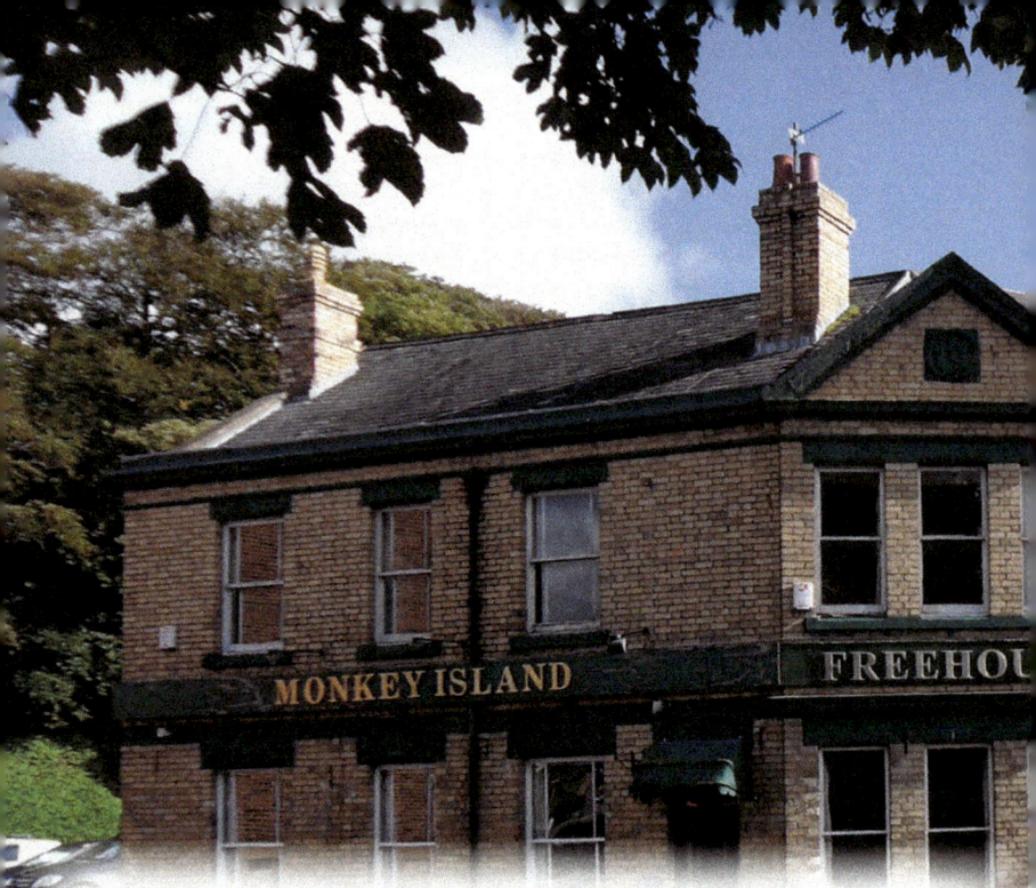

3. CASTLE STREET

At The Strand end of Queen Anne's Walk turn left along Castle Street. This area looks very different now, although the house on the far right appears the same in both photos. The corner building in the early photo is the Castle Inn, which appears to be boarded up prior to demolition. It was replaced by another public house which has had various names, the latest being Monkey Island. That name refers to the artificial lake and island created in the nineteenth century where the civic centre stands today. Its official name was Cyprus Island, but it was nicknamed Monkey Island, possibly because the architect, R. D. Gould, was supposed to resemble a monkey.

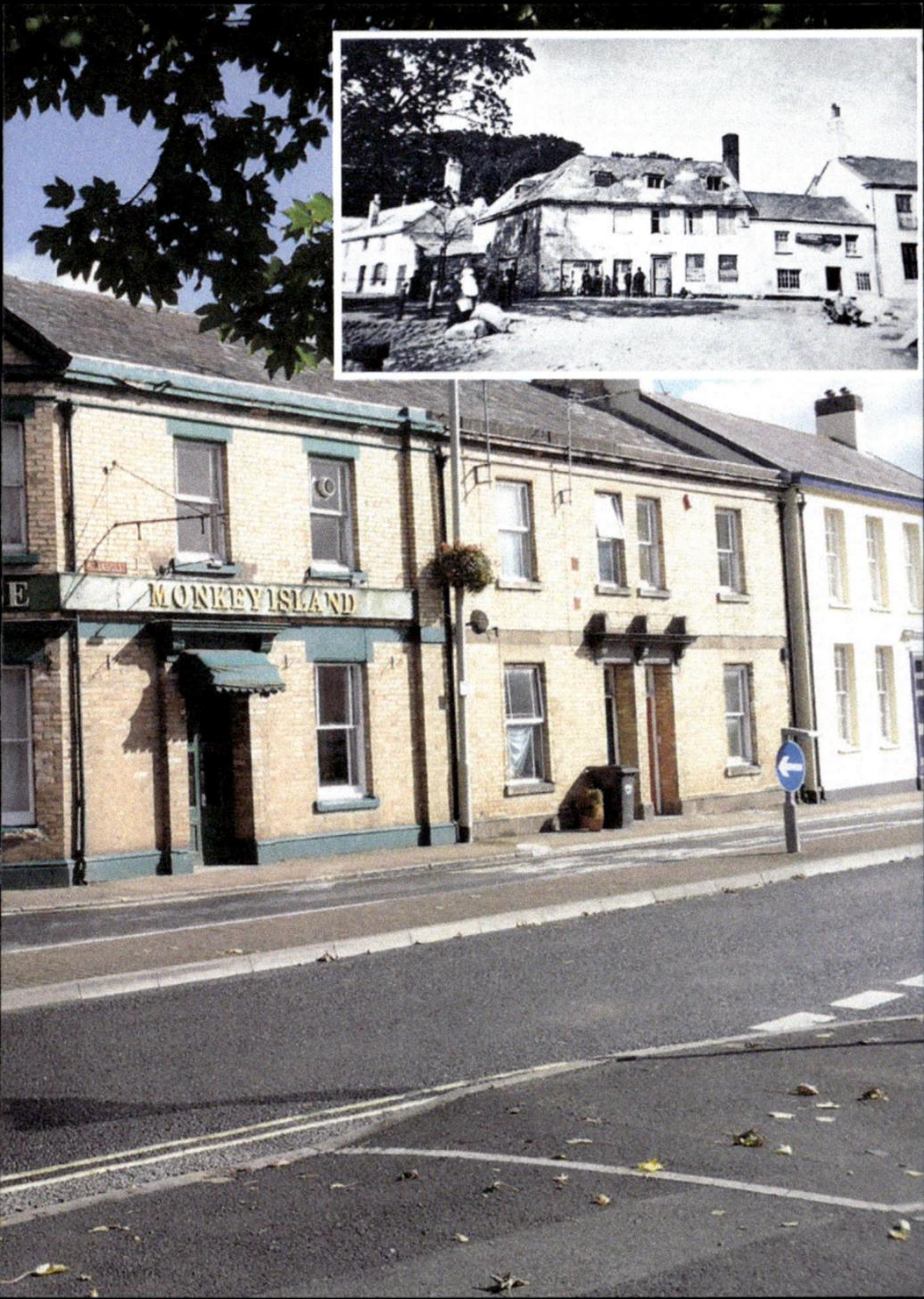

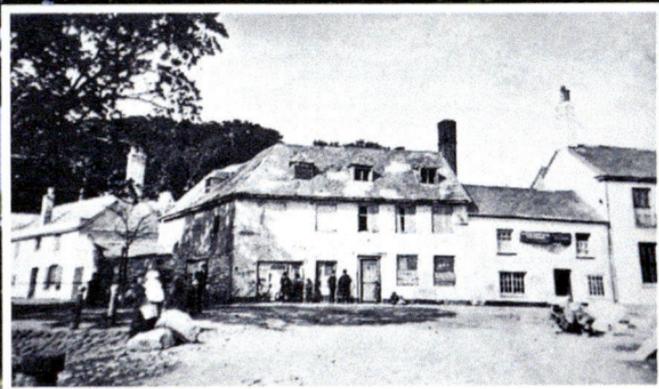

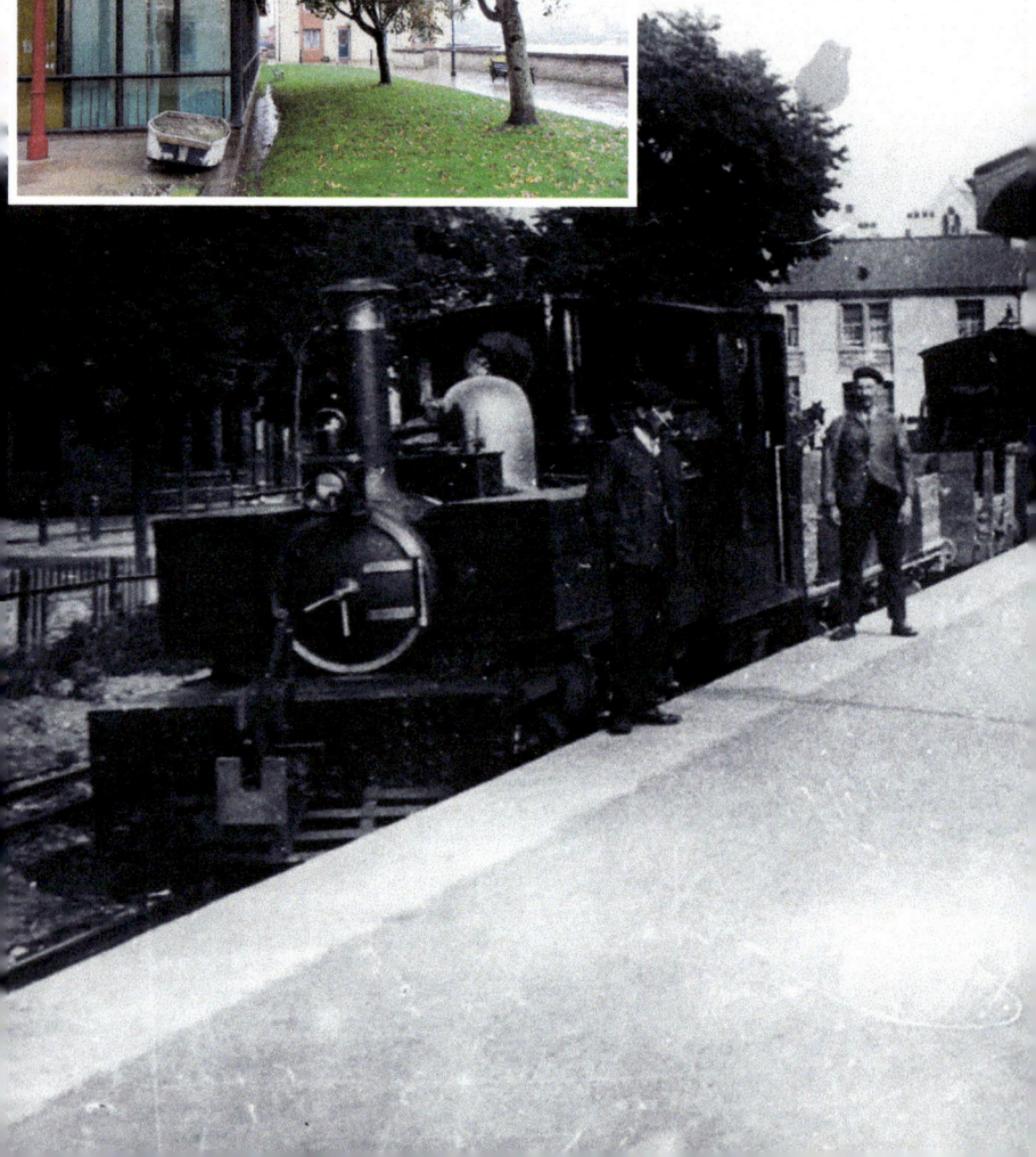

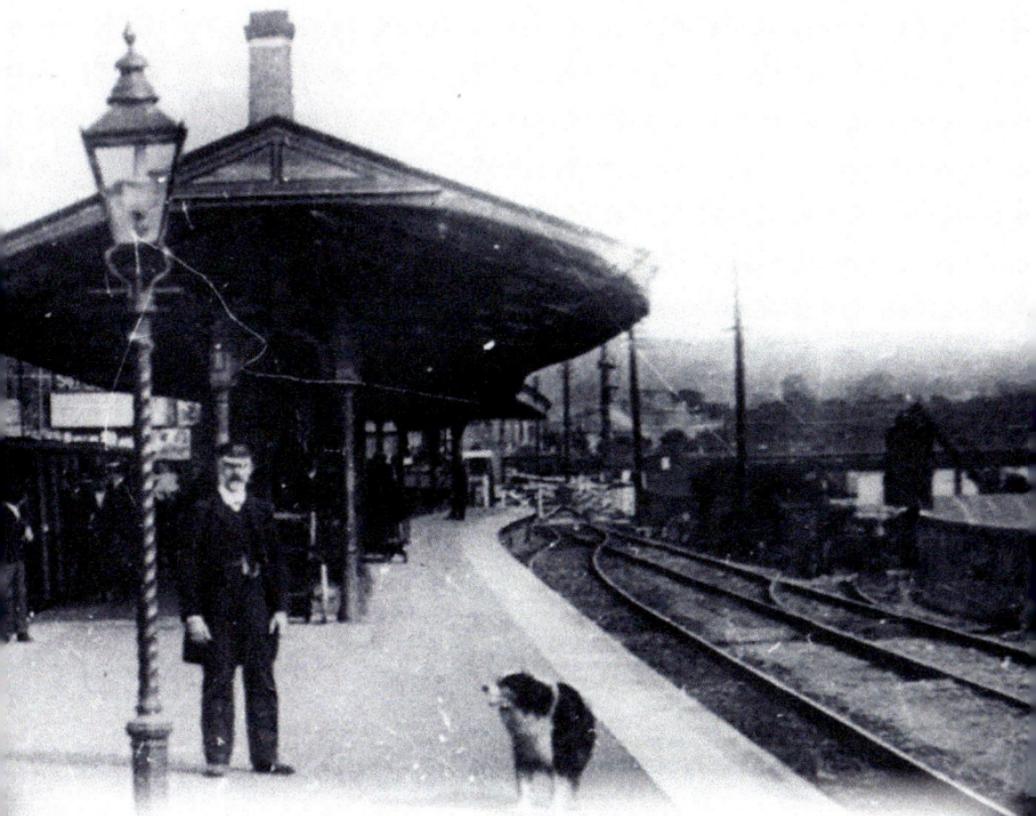

4. OLD RAILWAY STATION

On the river side of the road can be seen the façade of the old Town railway station dating from 1898, replacing the 1874 Quay station, which later became the bus station and is now a café. The town station can be seen in the old photograph, when it was still a working station serving the Ilfracombe and Lynton lines. Trains to Lynton ceased in 1935 and to Ilfracombe in 1970. The first railway station in Barnstaple and the sole remaining one, known as the Junction, was opened in 1854.

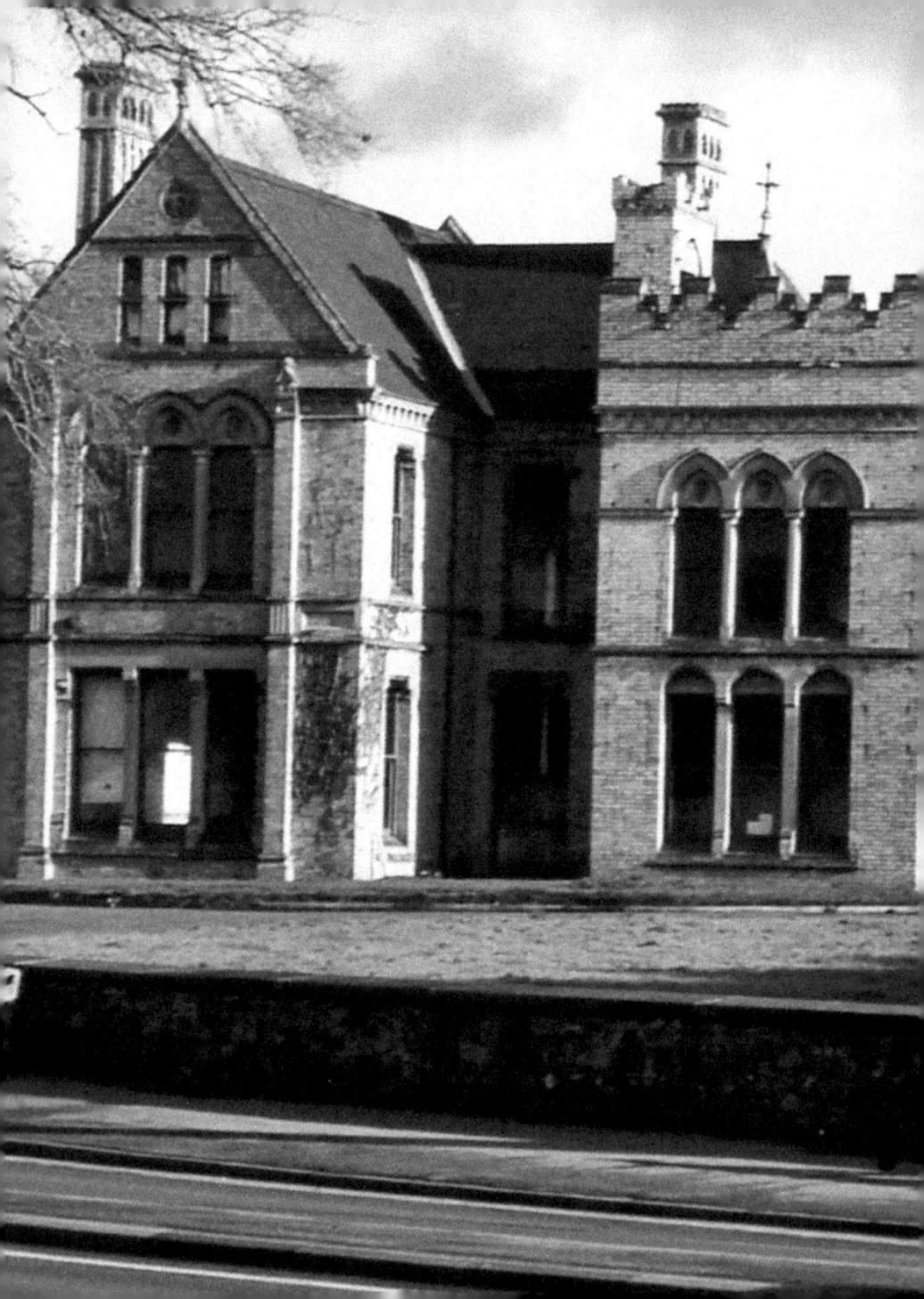

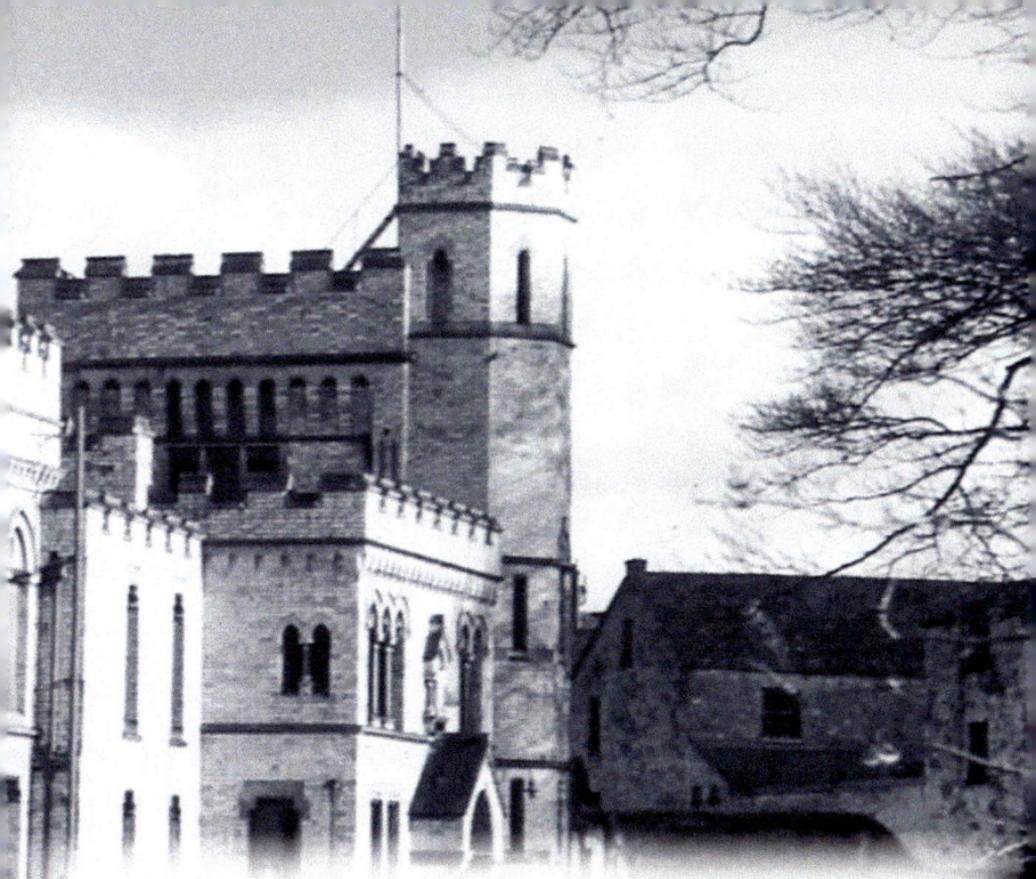

5. CASTLE MOUND I

Cross the road and continue along until you see the entrance to Castle Green. Walk through the Green taking note of the Castle Mound and the library. One building missing is Castle House, always known locally as 'the Castle' and shown in this photo. A Victorian building, it was occupied by the last private owner of this area, Mr. W. F. Hiern, a famous botanist who catalogued the botanical sections of the British Museum library. During his ownership large greenhouses were constructed against the walls of the house. Following his death, the house was purchased in 1926 by Barnstaple Borough Council for use as offices. It was demolished in 1976 to the lasting regret of many older residents.

6. CASTLE MOUND II

Walk along the path between the Castle Mound and the library. Unusually, this photo was taken from near the top of the Castle Mound, a very good viewing point from which to look over the town. The car park below occupies the site previously occupied by the Cattle Market animal pens, which closed in 2001. Although various animal markets had been held in the streets for centuries, the purpose-built Cattle Market was opened in 1848. Markets were usually held on Fridays to coincide with the main produce market in the Pannier Market. The mound and the remains of a ditch are all that remain of the motte-and-bailey castle built here sometime before 1100. By 1500 there was little left and the grounds were later used as a public space with several potteries in the area.

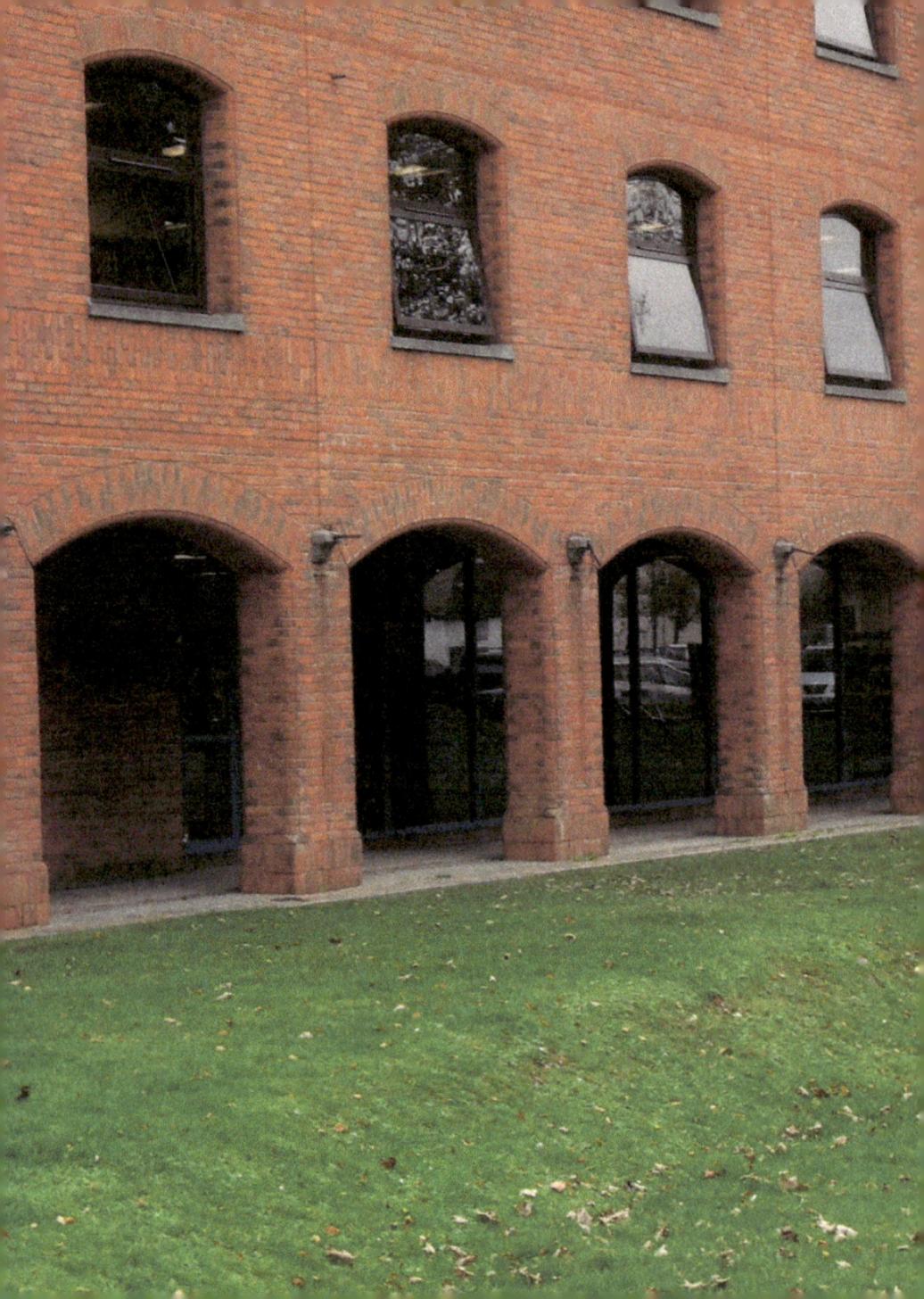

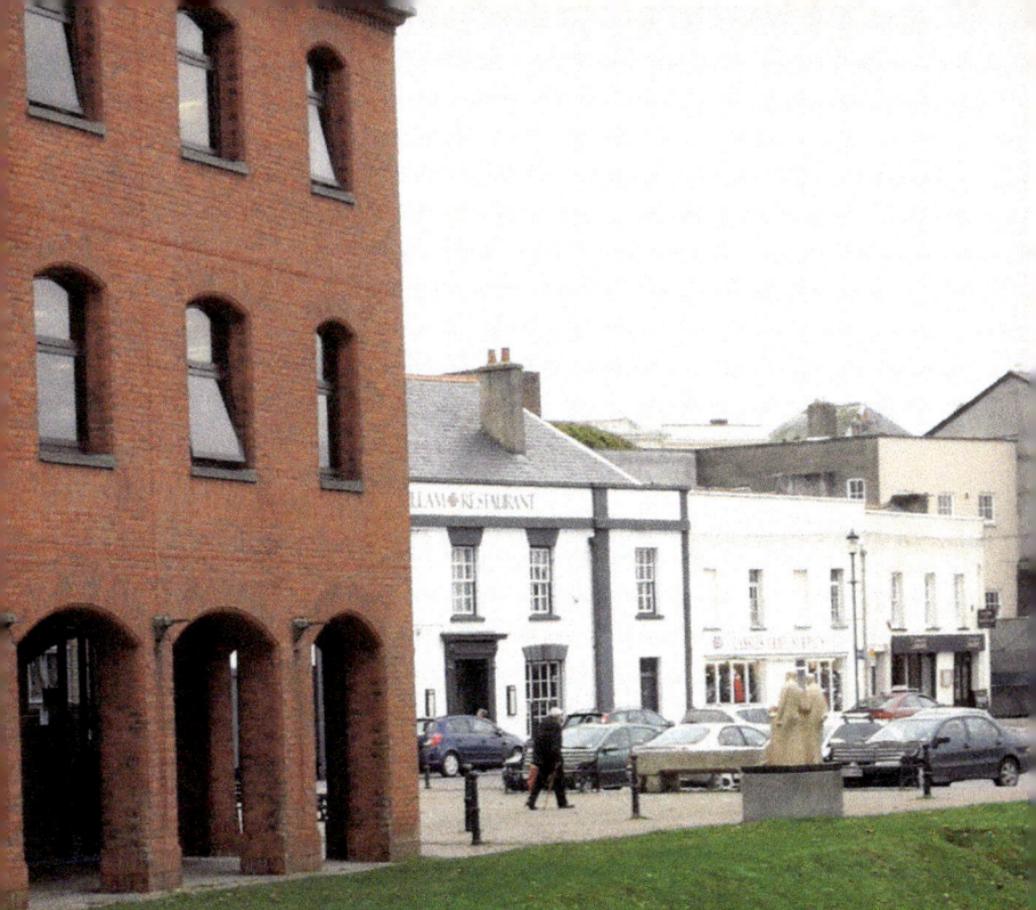

7. LIBRARY I

In contrast to the ancient Castle Mound, on the other side of the path is the library and North Devon Record Office, opened in 1988. Previously all records were held at Exeter, which meant a lot of travelling for anyone wishing to consult original documents. This area has changed enormously as can be seen from the old photo, taken before the library was built. In earlier centuries the site was occupied by the bridewell, an early form of workhouse.

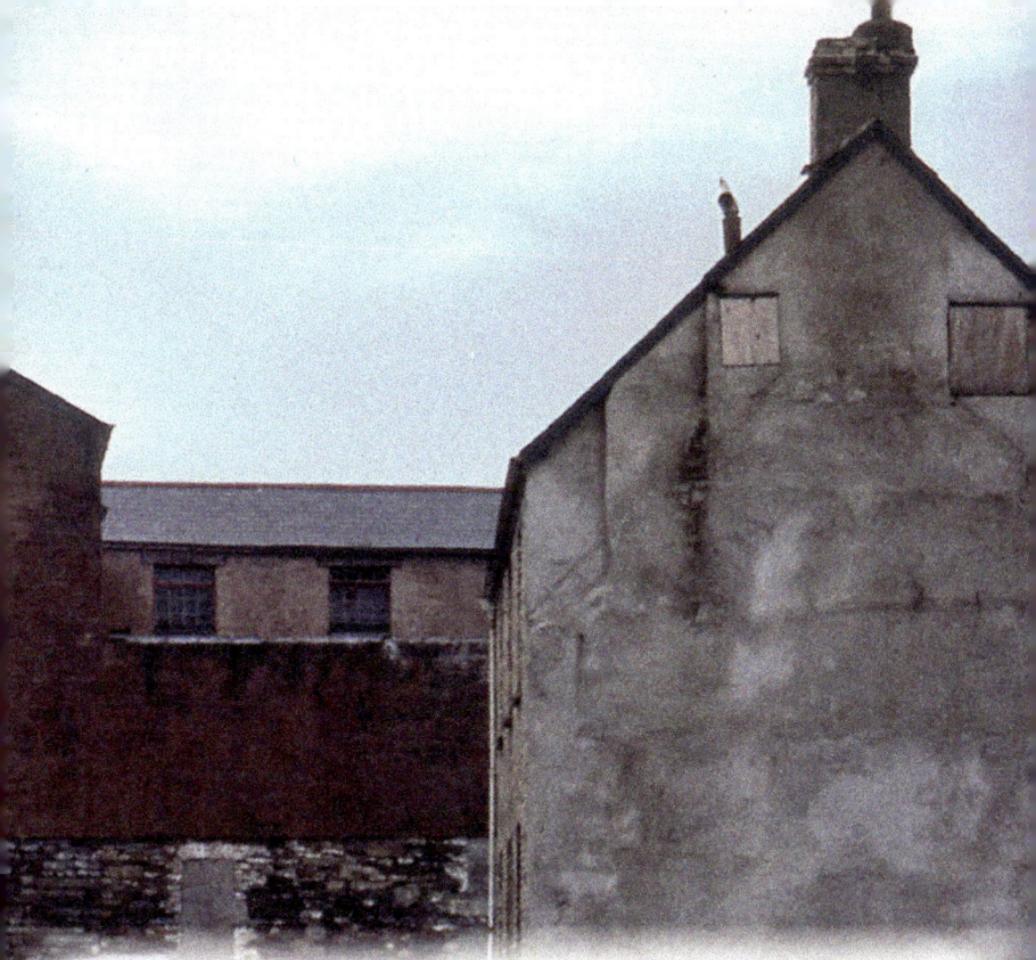

8. LIBRARY II

The old buildings before demolition are shown in this old photo, which is now the library car park and the rear of the library building. The buildings were part of the Dornat's mineral water works, which operated on the site from around 1870 until 1980, when Richard Youings, a descendant of the Dornat family, retired. There were plans to convert the buildings for use as an entertainment centre, including an ice rink, but eventually the old buildings were demolished and the library constructed.

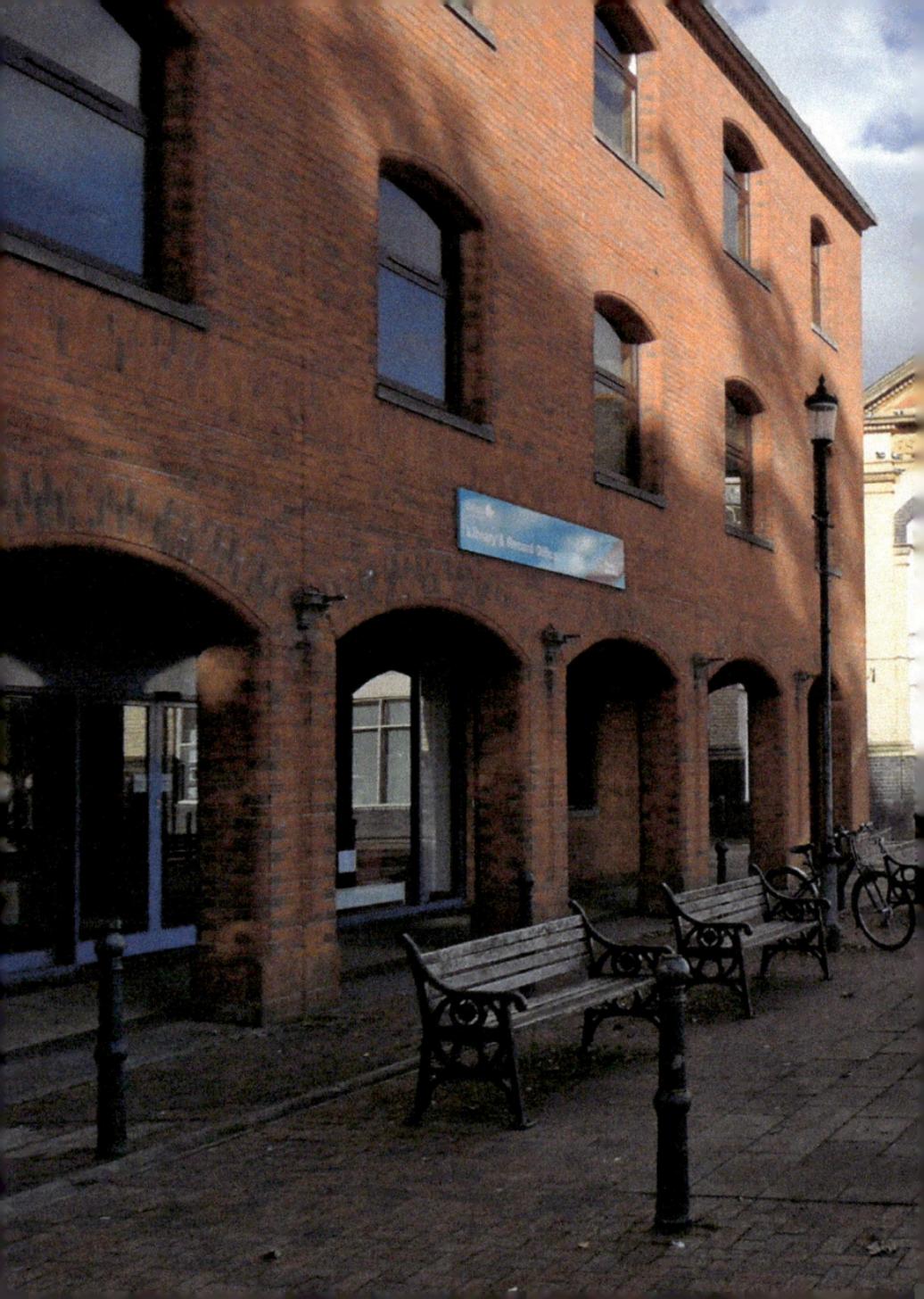

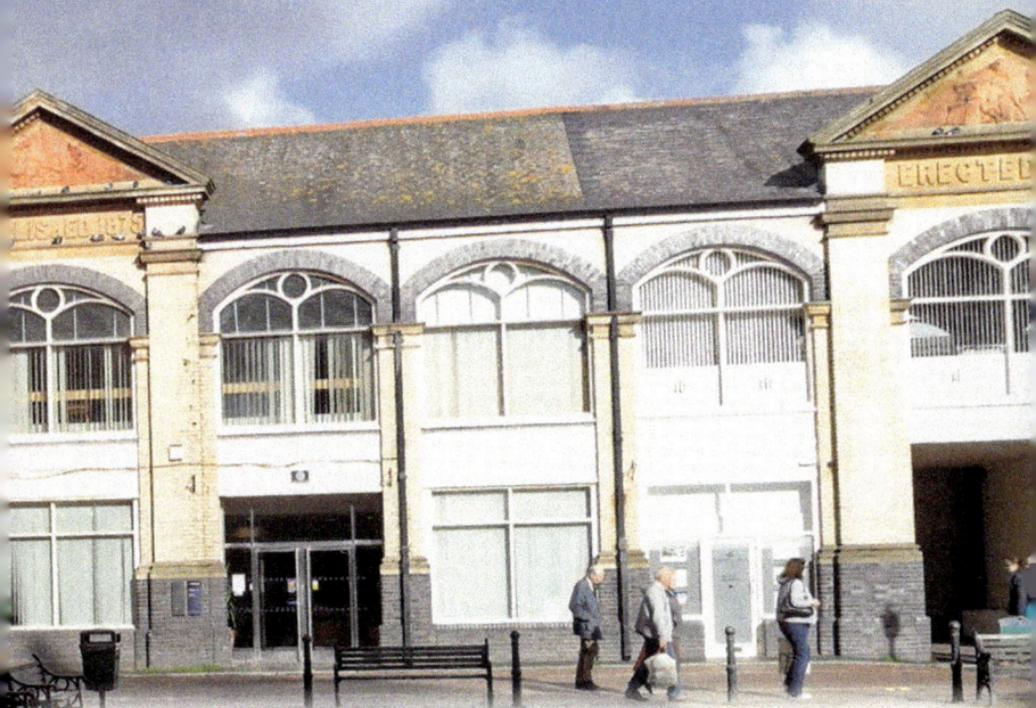

9. SQUIRE & SON BUILDING

Across the road (Tuly Street) from the library can be seen the frontage of the Squire & Son building. Dealers in agricultural machinery and implements, they had begun trading in 1875. Their High Street premises extended to a garden in Tuly Street and in 1903 they built new showrooms here, designed by Alexander Lauder who was also responsible for the terracotta panels showing ploughing and reaping. The business later became Gliddon and Squire.

10. GAMMON WALK

Cross over Tuly Street and into Gammon Walk to the left of the Squire & Son building. This was previously known as Gammon's Lane and was a mainly residential street, but the houses were demolished in the redevelopment of this area in the 1980s and '90s. In April 1838 an unusual notice in the *North Devon Journal* headed 'To the Curious in Flowers' announces that a Mr Payne of Gammon's Lane had around 500 Auriculas, which he offered to exhibit to visitors free of charge. Older residents of Barnstaple may remember the town's first discotheque, the Penny Farthing, was established here.

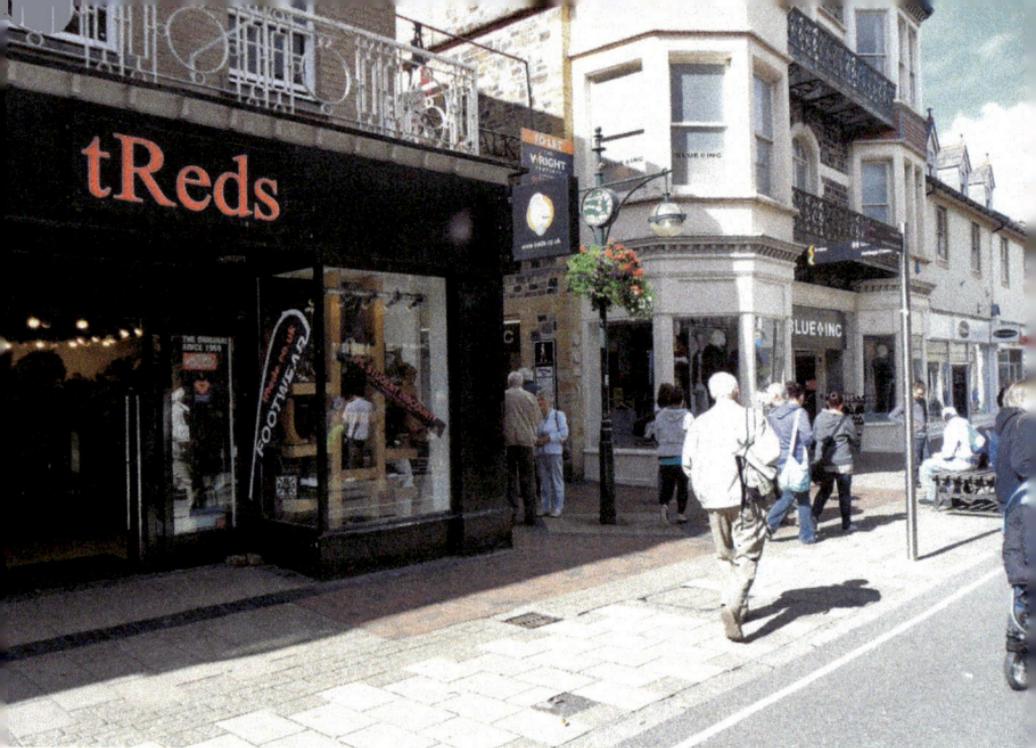

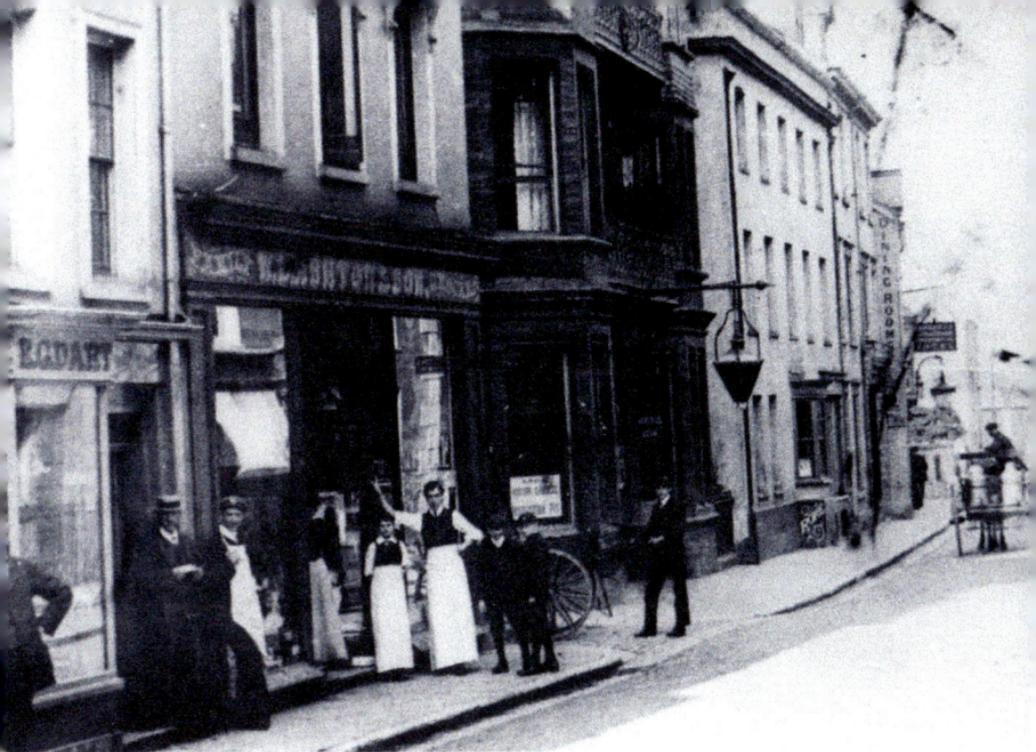

11. HIGH STREET – NORTH END

Turn right at the top of Gammon Walk into High Street. This is the north end of High Street and was long known as Northgate Street, as the southern end was known as Southgate Street. The names referred to the early medieval gates in the town wall. The photo shows the entrance to Gammon Walk on the left. The old photo, dating from around 1900, shows Ashton's family grocer with the staff posing outside their building, which has now disappeared to be replaced by the building shown in the modern photo. The building on the other side of Gammon Lane is the same in both photos. Opened in 1888 as the Victoria Temperance Hotel, it later housed council offices and is now known as Victoria Chambers. Turn right.

12. JOY STREET I

Cross High Street and continue walking until you reach Joy Street. Turn left and walk halfway up the street until you reach the entrance to Market Street on the right. Joy Street was for centuries the only road through from High Street to Boutport Street. In the fifteenth century Joy Street was known as Eastgate Street, a reference to the East Gate which once stood at the Boutport Street end. The new name was in use from at least 1578 and may relate to a family called Joy or Joye who lived there.

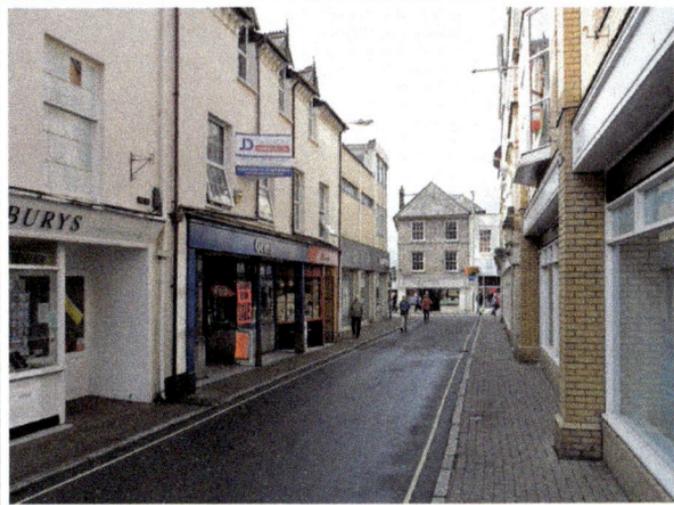

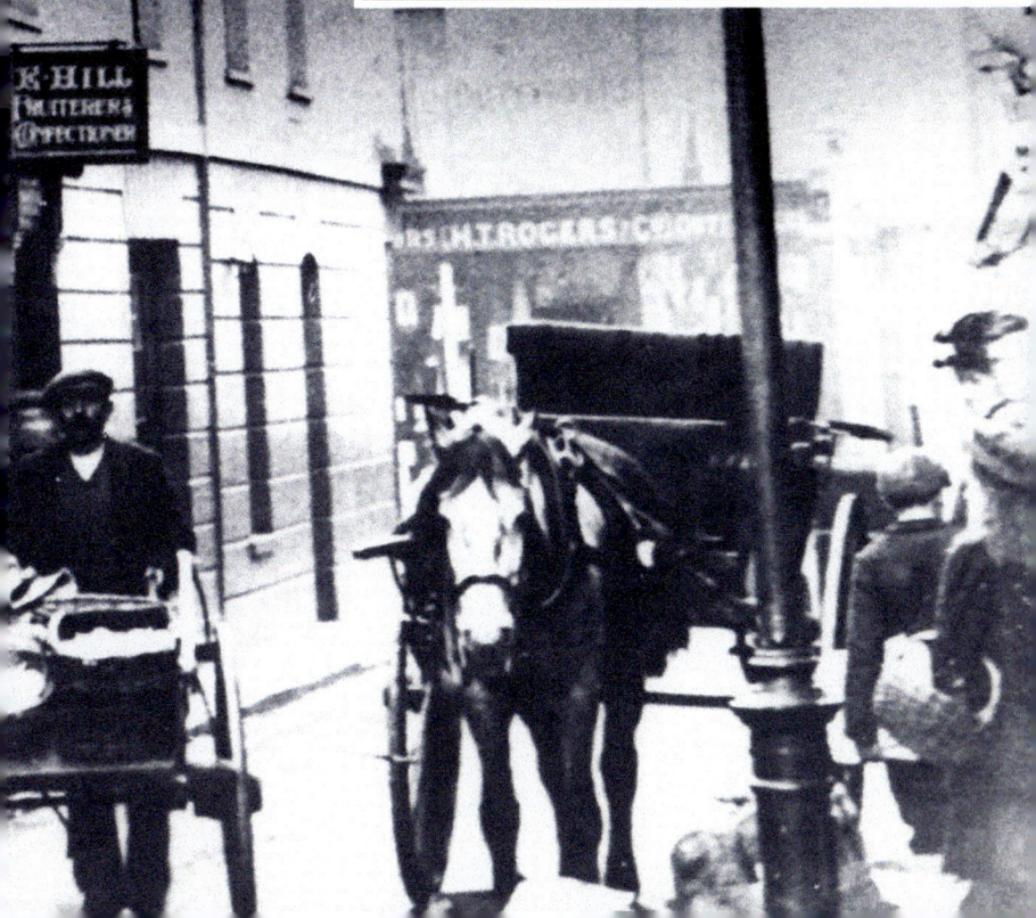

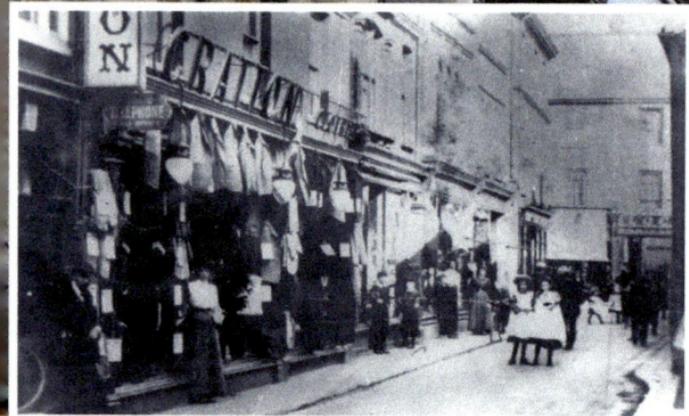

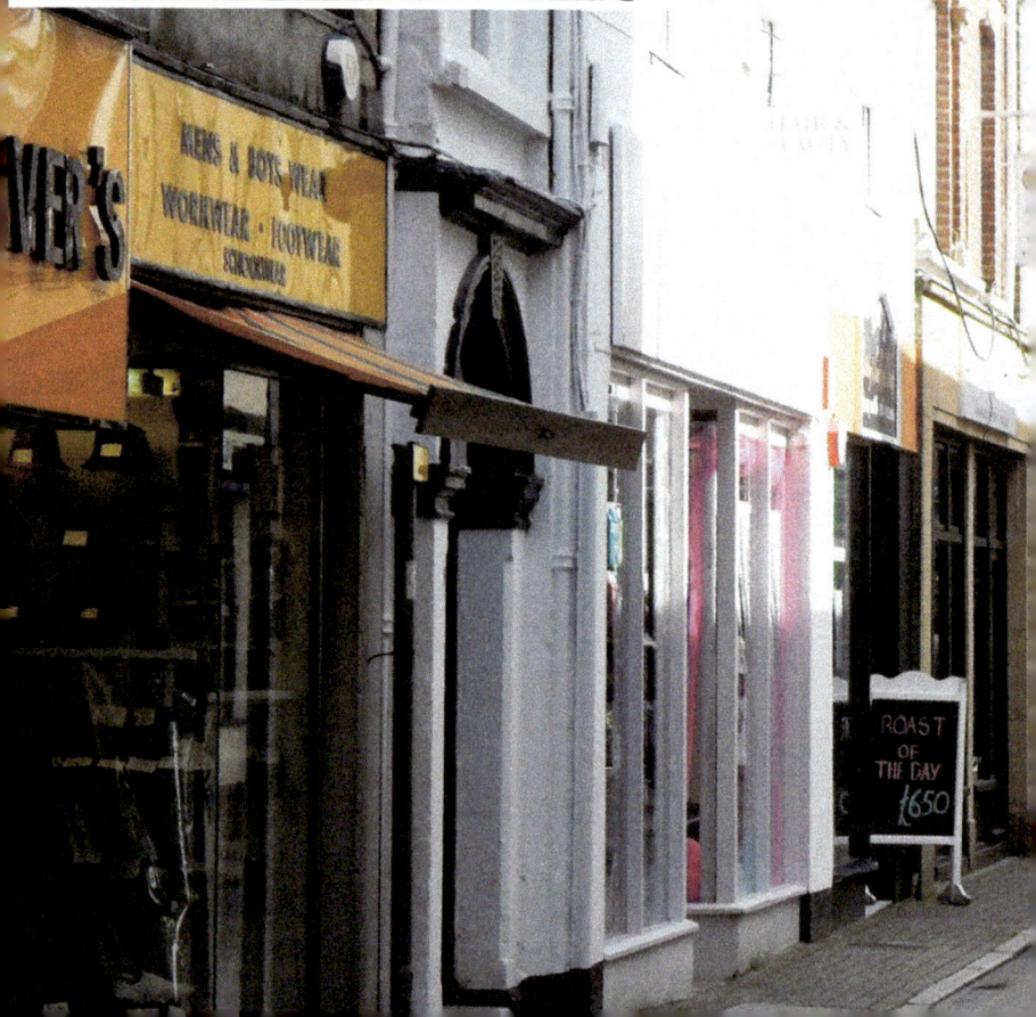

MENS & BOYS WEAR
WORKWEAR · FOOTWEAR
SCHOOLWEAR

ROAST
OF
THE DAY
£650

13. JOY STREET II

This photo is taken looking towards the High Street. Many of the old buildings in Joy Street have been replaced, either completely or partially, and their occupants have changed often, even in recent years. One of the businesses which survived in the same family for a considerable time is seen in the old photo. The sign in the old photo announces that R. Hill was a fruiterer and confectioner, but their occupation soon changed and the firm is best remembered now as a watch repairers and jewellers.

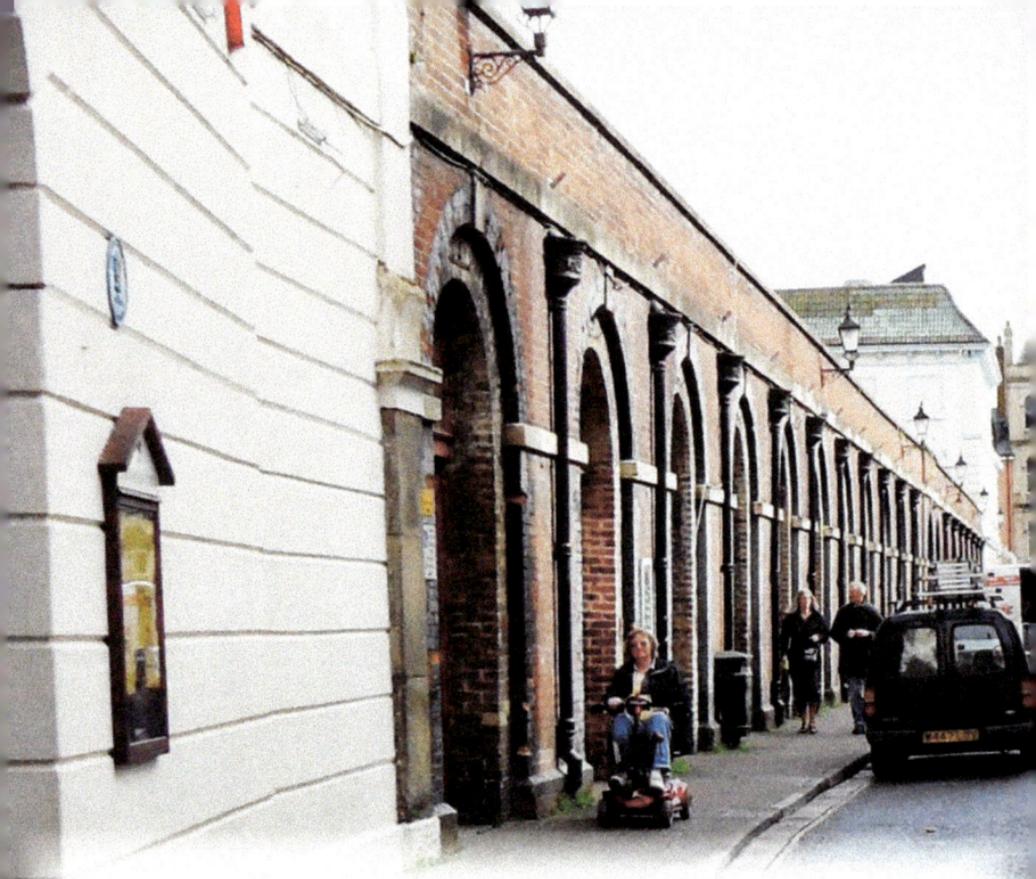

14. MARKET STREET AND BUTCHER'S ROW

Walk along Market Street (formerly known as Anchor Lane), through the Pannier Market and out into Butcher's Row, shown in this photo. The market is built onto the Guildhall, which dates from 1826 and part of which is visible on the front left of the picture. Both the market and Butcher's Row were constructed in 1855–56 and designed by the Borough Surveyor R. D. Gould. Several buildings were demolished to make way for the new construction. Butcher's Row comprised thirty-three open-fronted shops, each with a frontage of 10 feet 10 inches. It was exclusively a meat market until the Second World War when rationing was introduced.

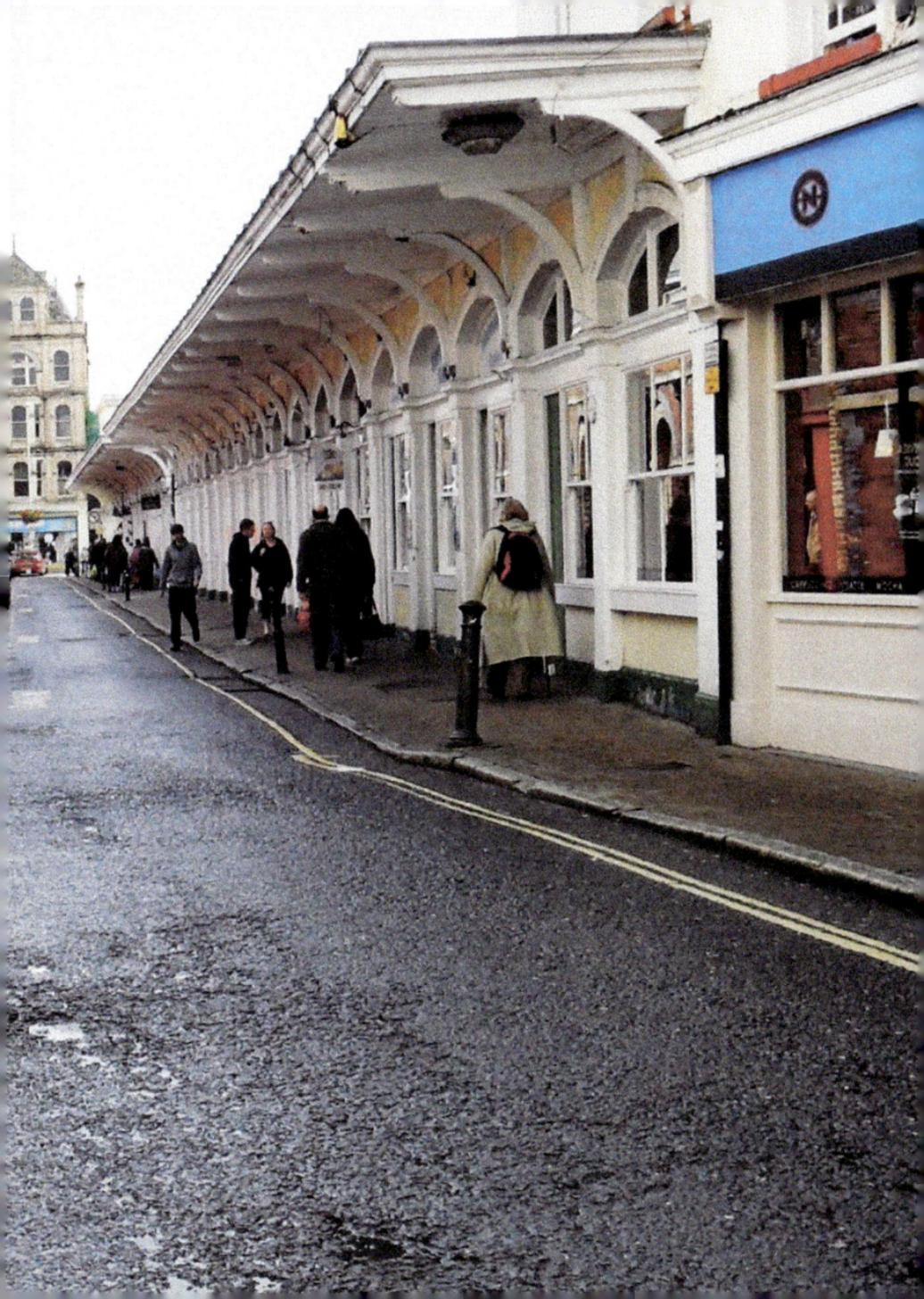

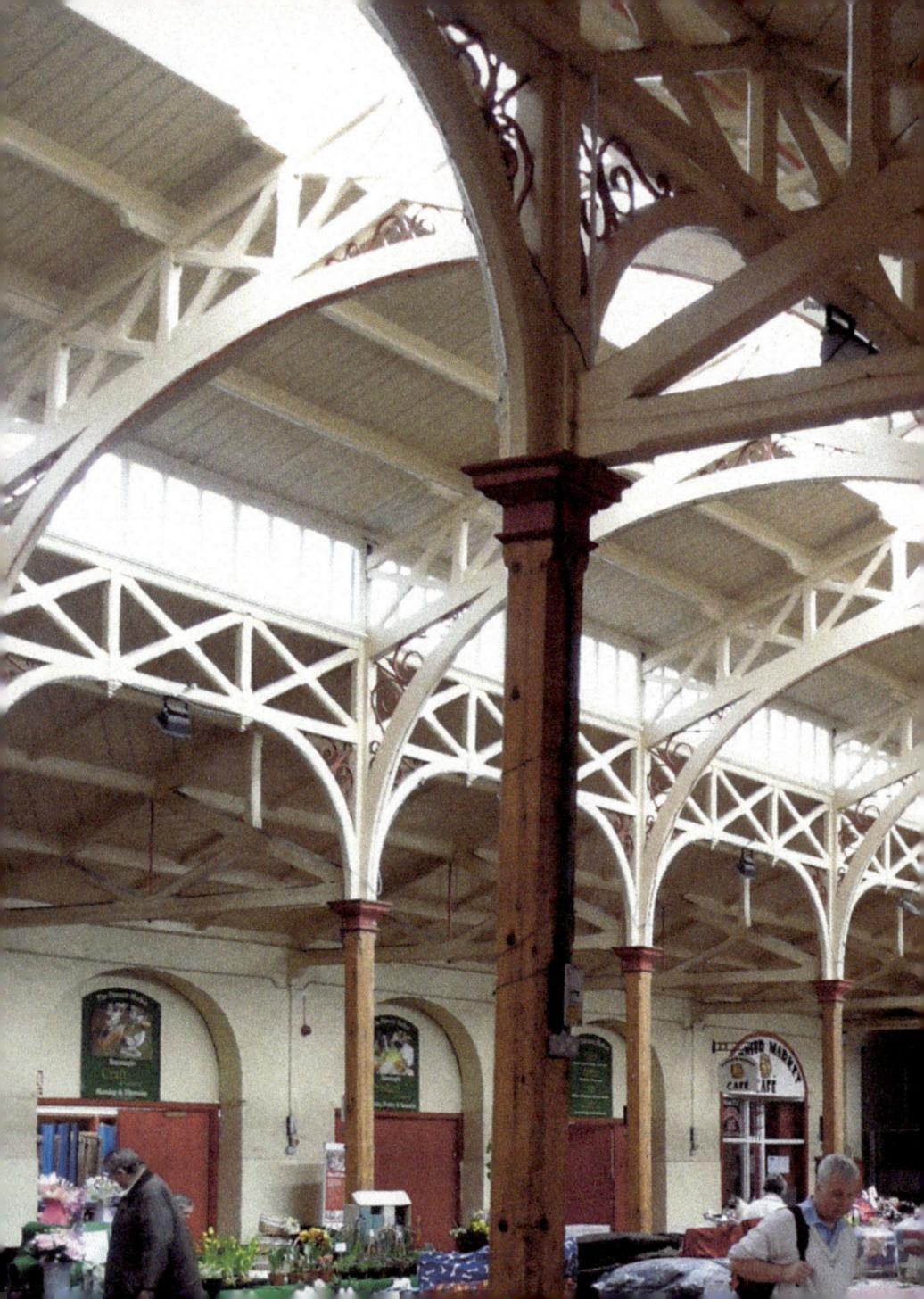

15. PANNIER MARKET

For centuries Barnstaple's market was held in the open streets, but by the 1850s the town was growing and it was decided a covered space was required. Although at the time many were opposed to the project, it is still in use for its original purpose over 150 years later.

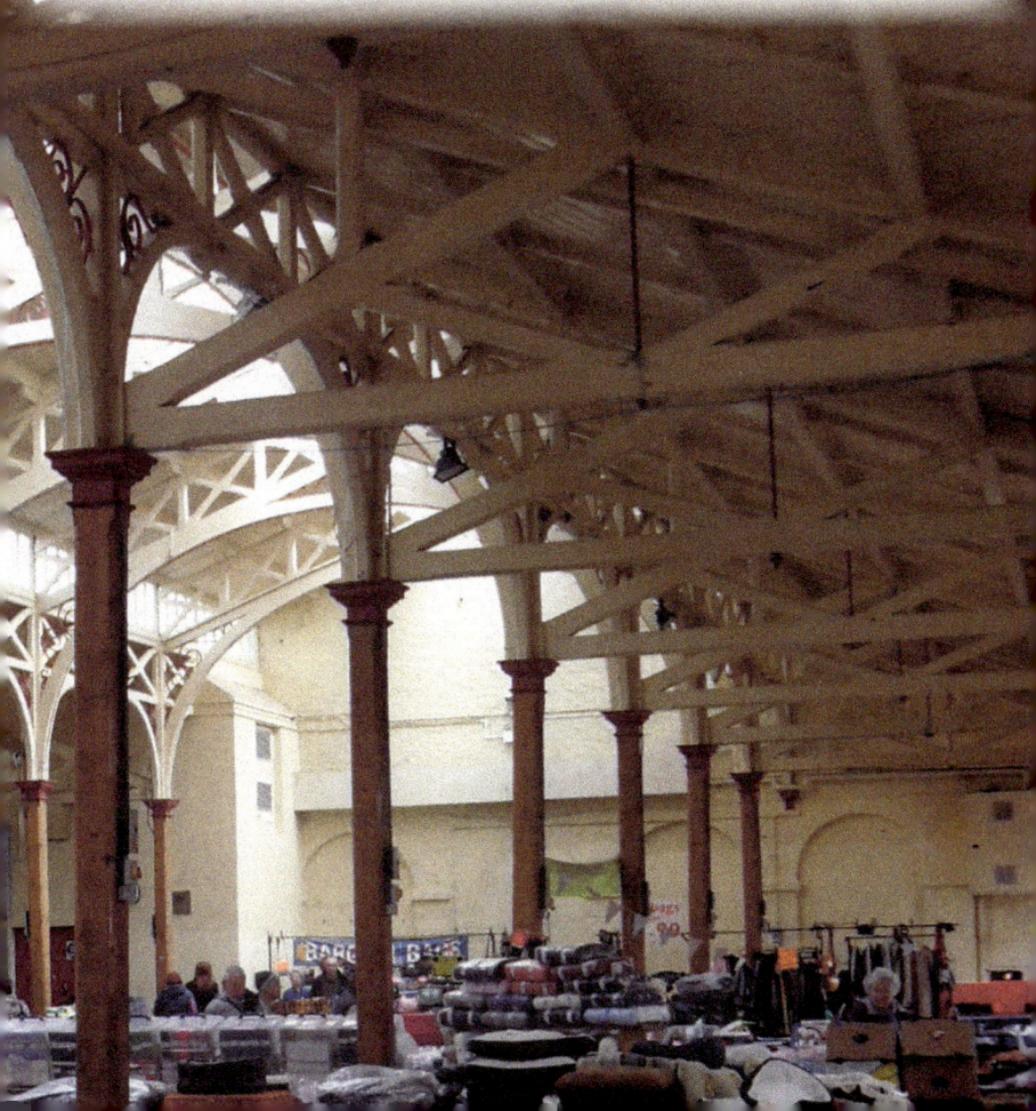

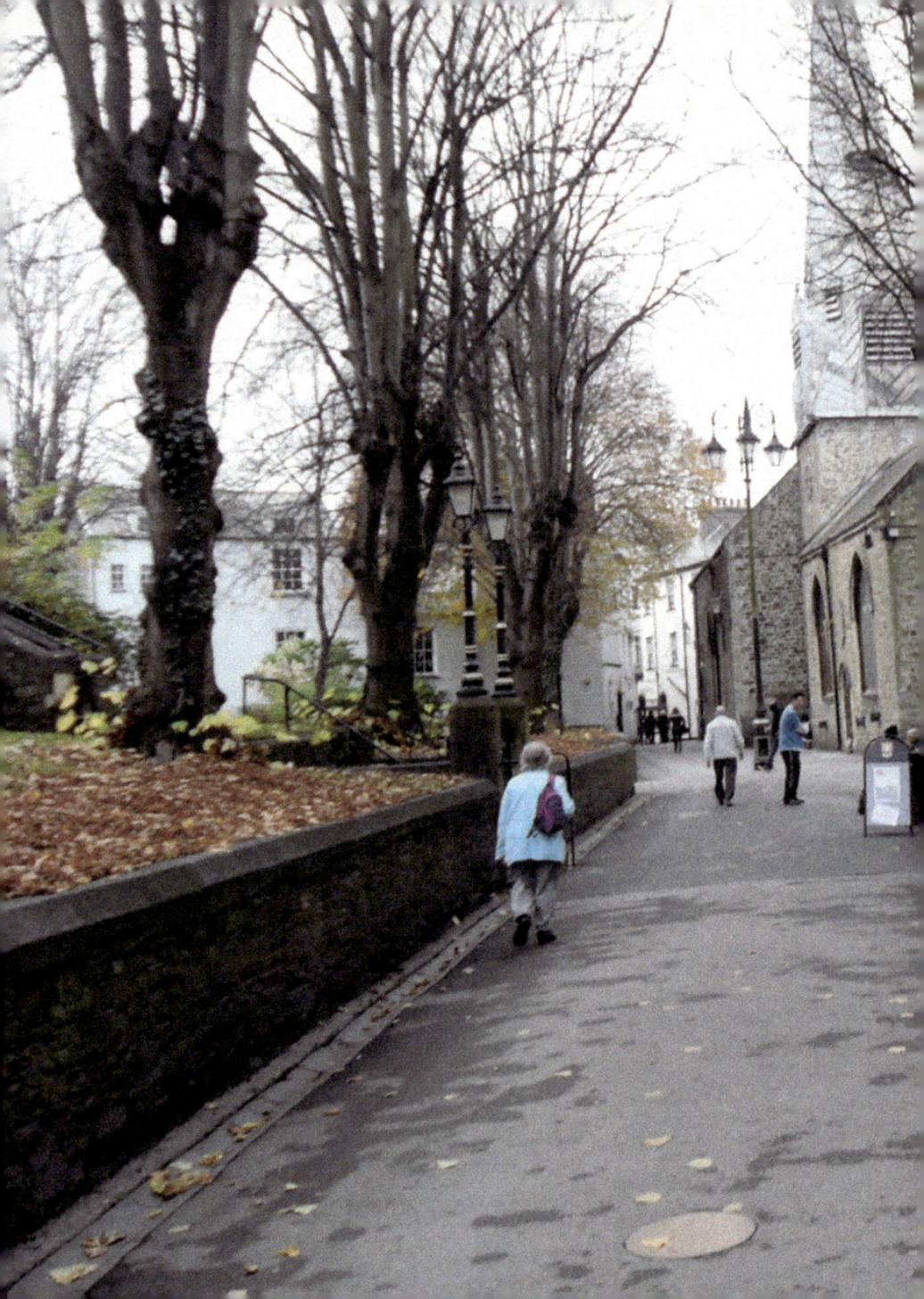

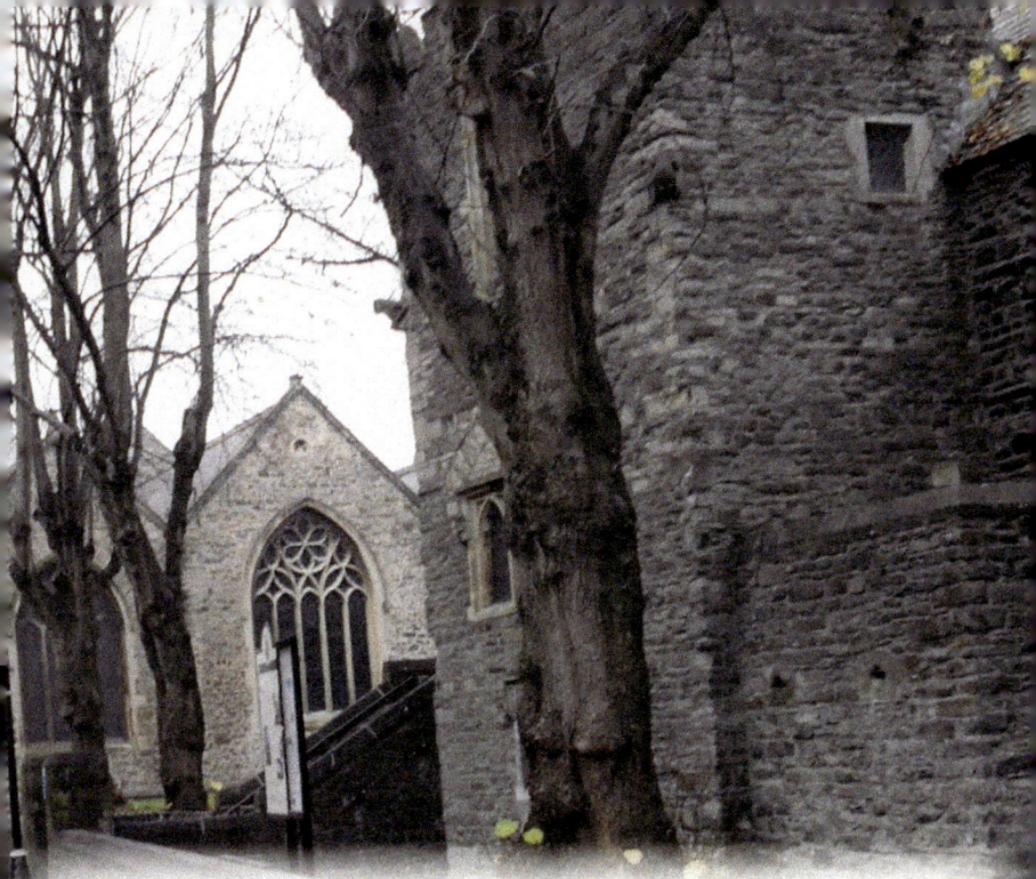

16. PATERNOSTER ROW – ST ANNE'S CHAPEL

Walk through the short lane opposite Market Street into the churchyard. The photo is taken from the Boutport Street end looking towards the High Street. The building on the left as you enter the churchyard (but on the right in the photo) is St Anne's Chapel, built in the early fourteenth century, with the tower added around 1550 and restored in Victorian times. It has been a chantry chapel, the town's grammar school where John Gay (author of the *Beggar's Opera*) was educated, and the town museum. It is now an arts and community centre.

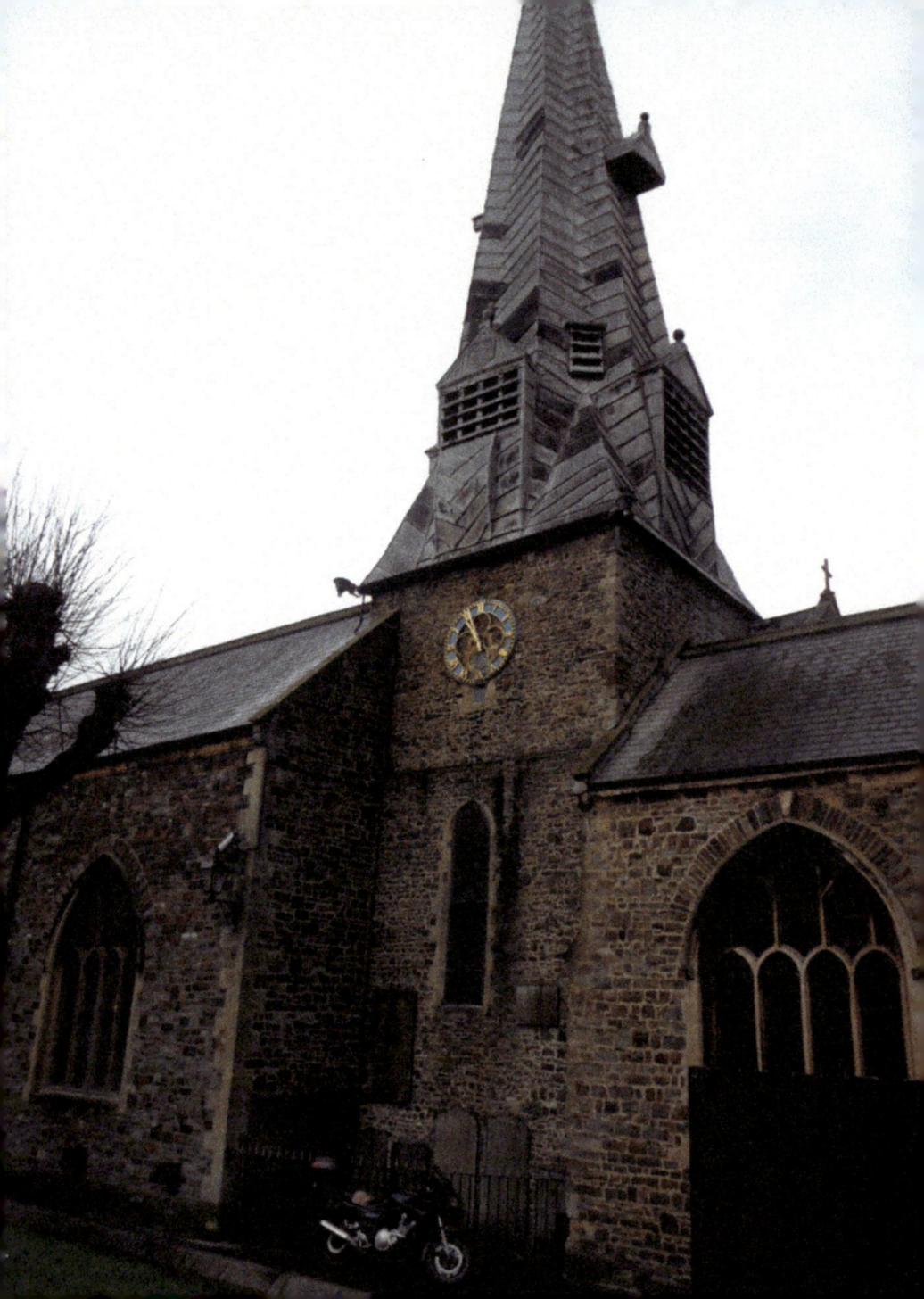

17. PARISH CHURCH

To your right is the parish church, reconsecrated in 1318 but founded much earlier. However, there had been a church here before that and the tower is thought to date from around 100 years earlier. The spire was added in the 1380s. Note the twisted appearance of the leaded spire, which may be due to the warping of the lead or a lightning strike in 1810. Opposite are the parish church rooms and former infants' school. These date from 1895 but were deliberately designed to echo the architecture of St Anne's Chapel.

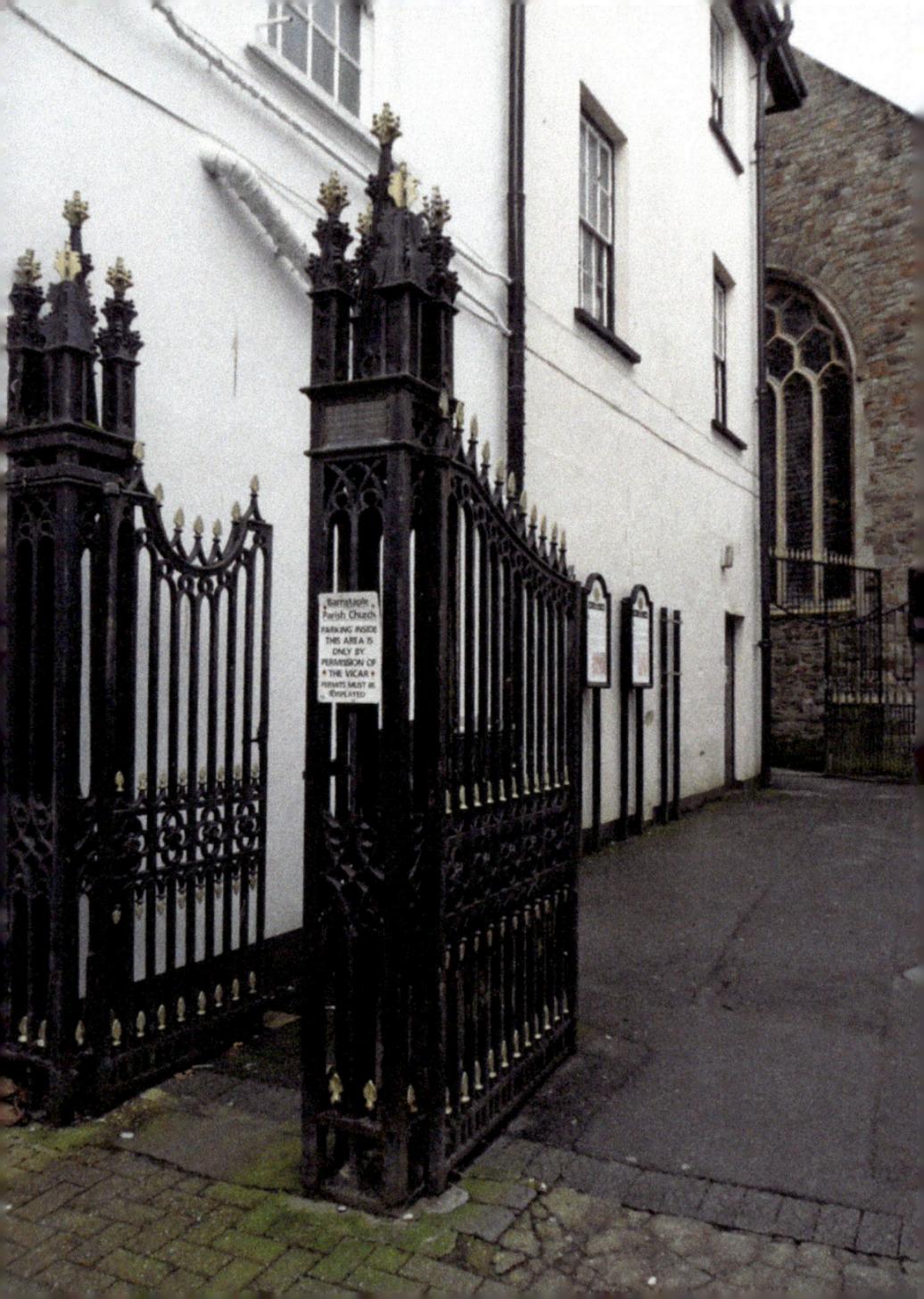

Barnstaple
Parish Church
PARKING INSIDE
THIS AREA IS
ONLY BY
PERMISSION OF
• THE VICAR •
PERMITS MUST BE
DISPLAYED

18. IRON GATES

Turn right and walk out into High Street through the iron gates constructed in 1830 by the local firm of Willshire. These were erected following the demolition of the old Guildhall, which had stood here from the mid-sixteenth century, and were considered a great improvement. As the *North Devon Journal* remarked about the new entrance to the churchyard, 'it forms a striking contrast to the old projecting Guildhall, and filthy covered way' which had previously formed the entrance.

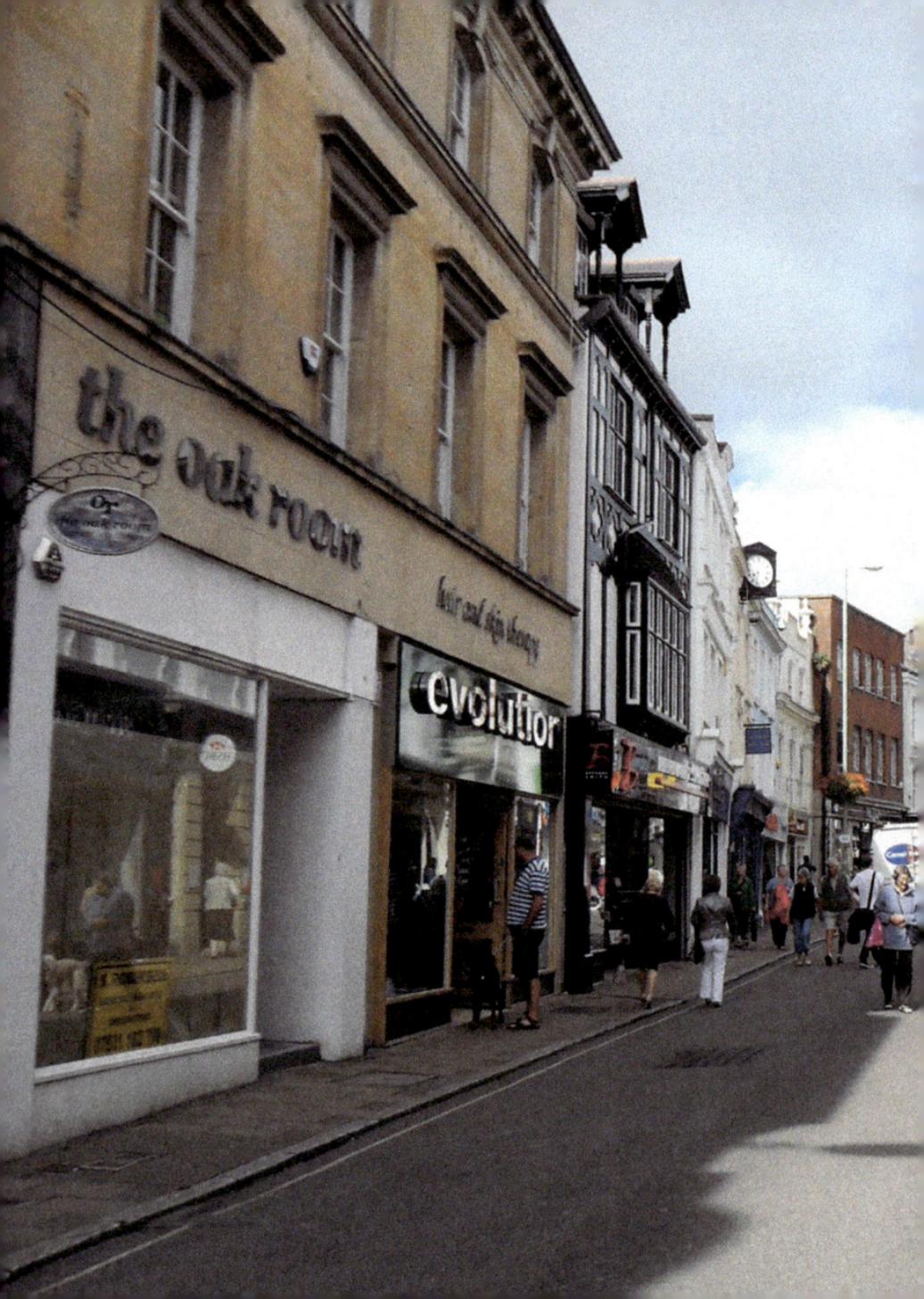

19. HIGH STREET – SOUTH END I

Turn left and walk along High Street towards its junction with Boutport Street. As with most old places it is necessary to look up to see evidence of the town's history, as at ground-floor level the majority of shopfronts are modern. There are several elaborate Victorian buildings, as well as some from the eighteenth century. The houses at both ends of High Street were residential in earlier centuries and many at this end stretched down to the Strand. No. 103 (now Woolacotts) is believed to be the site of Grace Beaple's house, where the fifteen-year-old Prince of Wales (later Charles ll) stayed for a few weeks in 1645 during the Civil War.

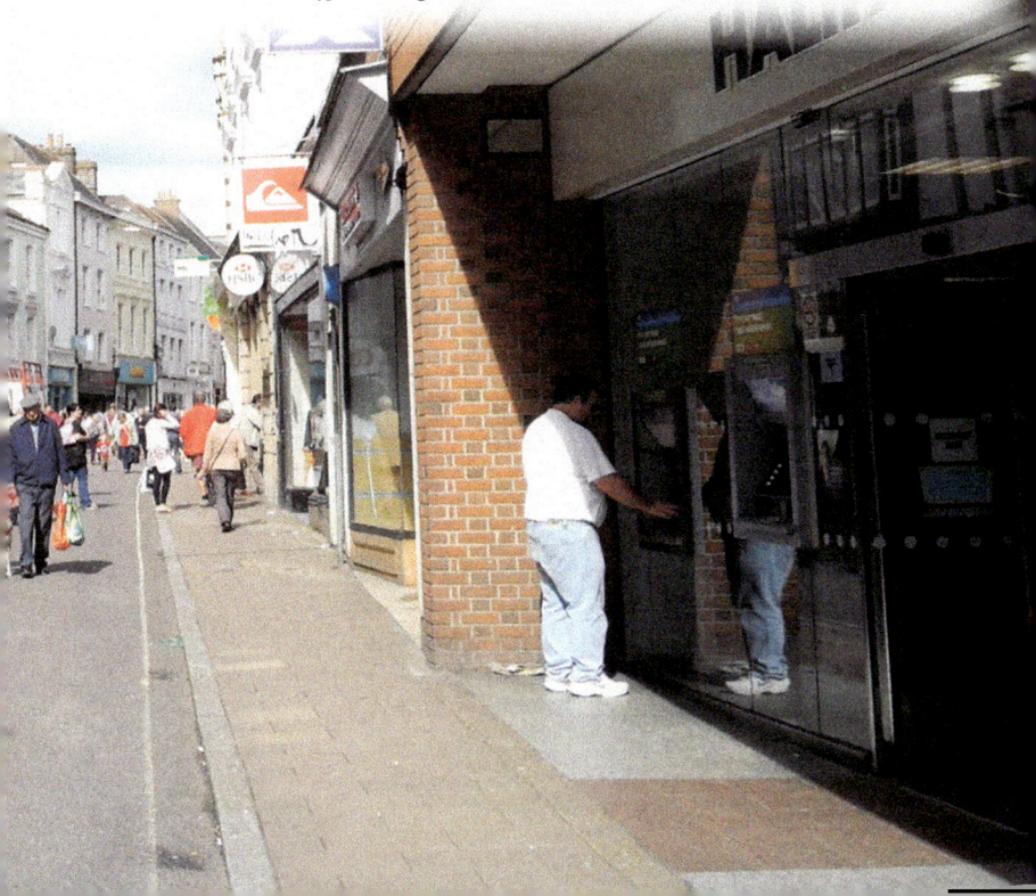

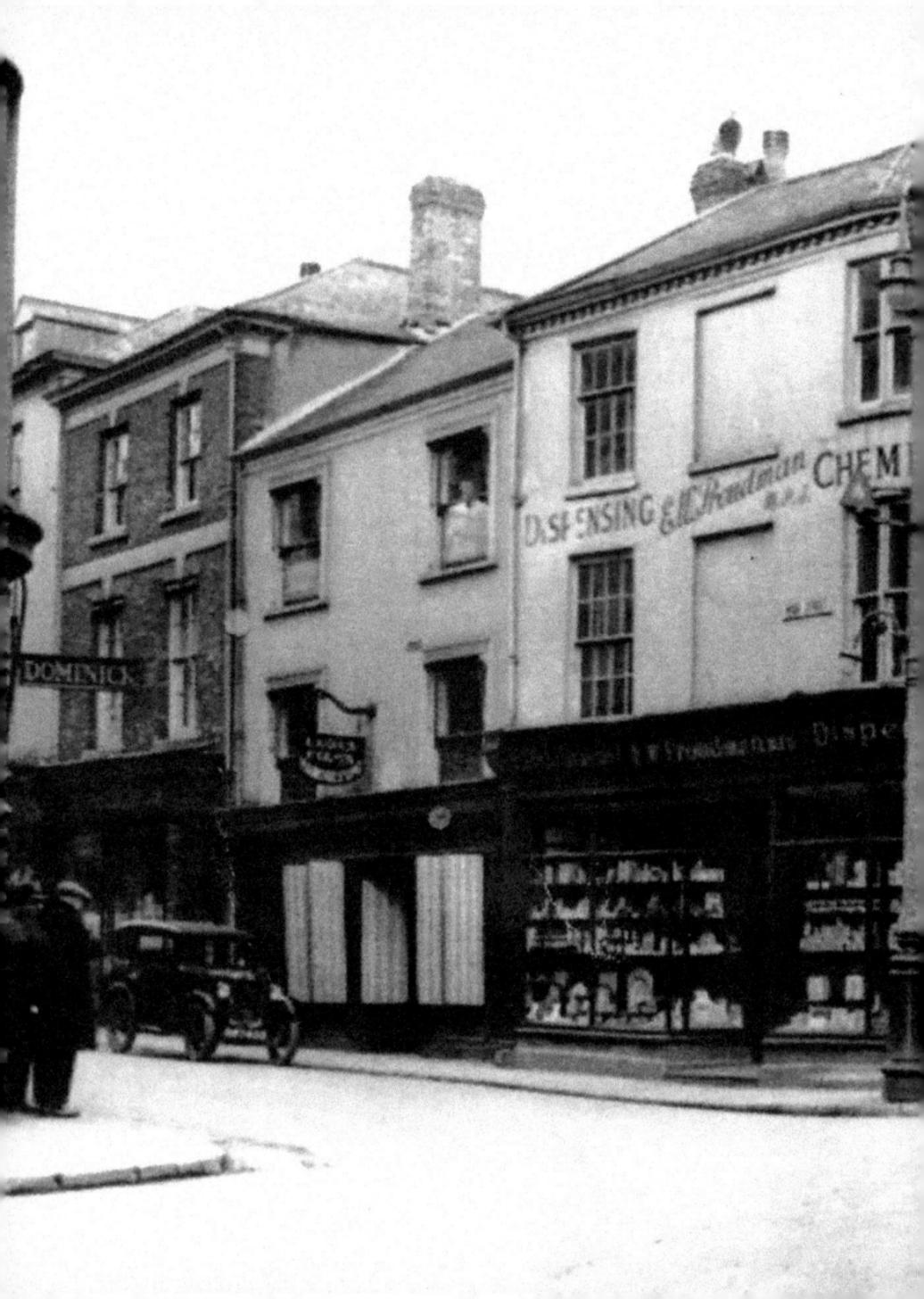

20. HIGH STREET – SOUTH END II

Stop and look around at the junction of High Street with Boutport Street. The most striking building on the corner is the Youings building, which dates from 1934, although the business began as a tobacconists in 1884 in a shop in Boutport Street. The photo shows E. W. Proudman's pharmacy, the building replaced by Youings, which is one of the few long-established family businesses to remain in Barnstaple. A piece of masonry from the old Southgate arch can be seen in the shop. Boutport Street means 'about the port or town' and is the street which grew up outside the early medieval town walls.

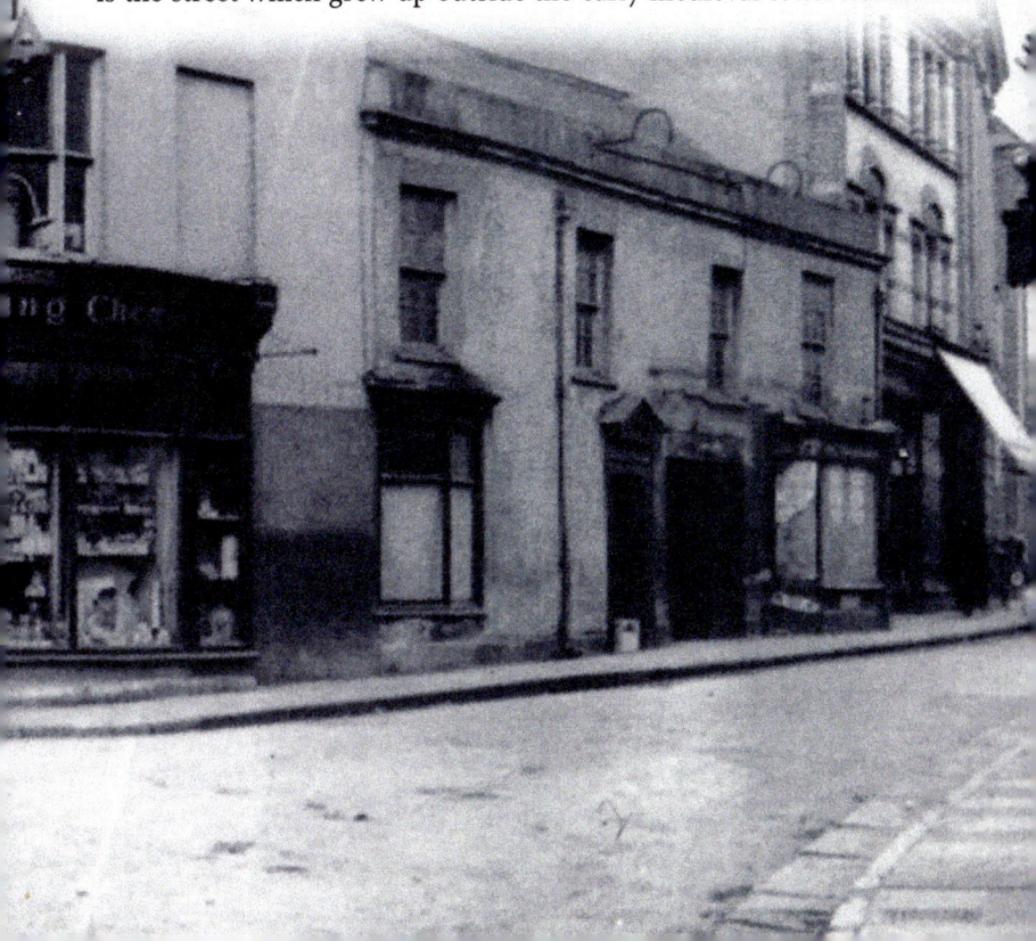

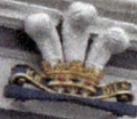

ROYAL & FORTESCUE HOTEL

COFFEE
HOUSE

HAND ROASTED
LOCAL COFFEE

CAKES &
PASTRIES

LIGHT BITES
& FULL MENU

AFTERNOON
TEA

21. ROYAL & FORTESCUE

Both the Royal & Fortescue and the Golden Lion (now the Bank restaurant) next door became coaching inns in the second half of the eighteenth century. The buildings are older and there is a splendid decorated plaster ceiling in the Bank from the early seventeenth century. Note the Prince of Wales feathers above the door of the Royal & Fortescue. These were added after the Prince of Wales (later Edward VII) stopped at the hotel for lunch during his visit to North Devon when he was a young man. It was after that visit that the 'Royal' was added to the name to further enhance the image of the hotel.

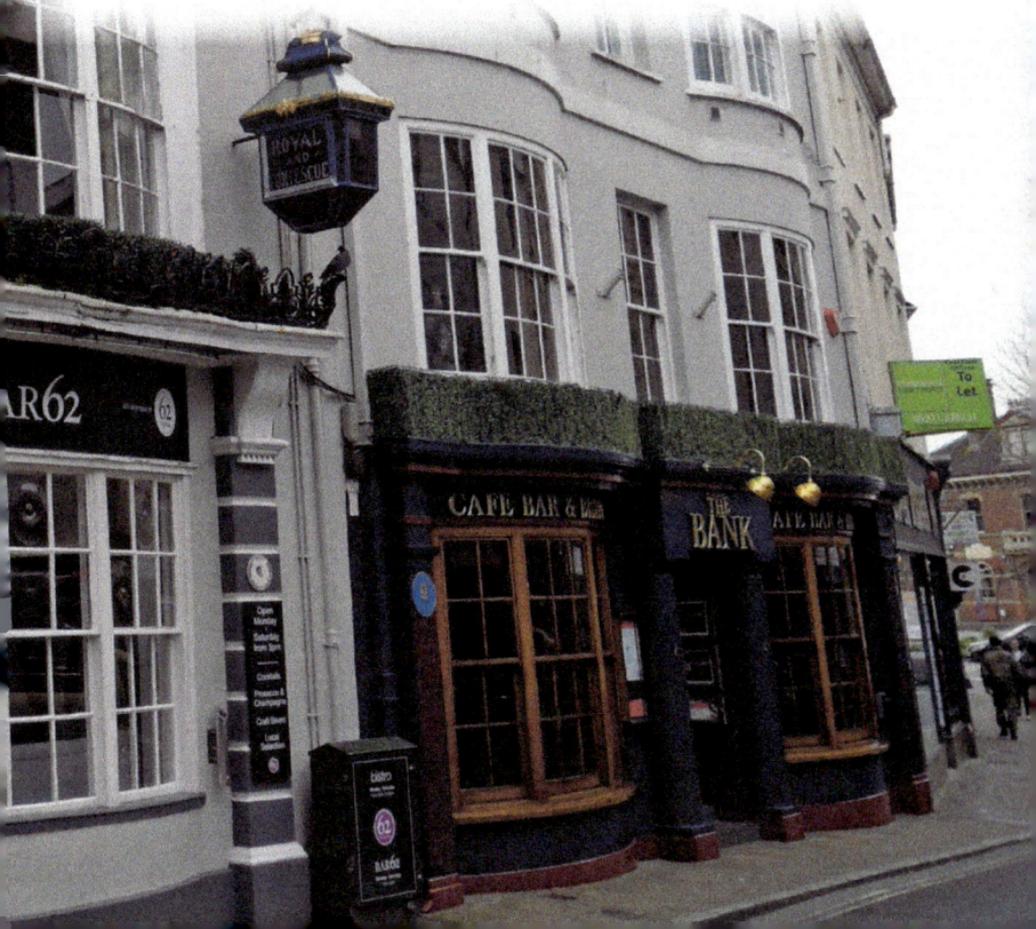

22. THE SQUARE

Continue down the street and turn right. Cross over to The Square, where the most prominent feature is the Albert Clock. It was constructed in 1862 as a memorial to Prince Albert, Queen Victoria's husband, who died in 1861. On the left of the photo the Museum of Barnstaple & North Devon can be seen. Built as a private house, it became the North Devon Athenaeum in 1888 when it was purchased by W. F. Rock. The Square has changed greatly over the years and until it was drained in the eighteenth century it was a marsh and there were also limekilns near the river. In the nineteenth century gardens were laid out and many alterations have been made since. The fountain and bust were erected in 1889 in memory of Charles Sweet Willshire, a popular and respected local councillor, magistrate and mayor.

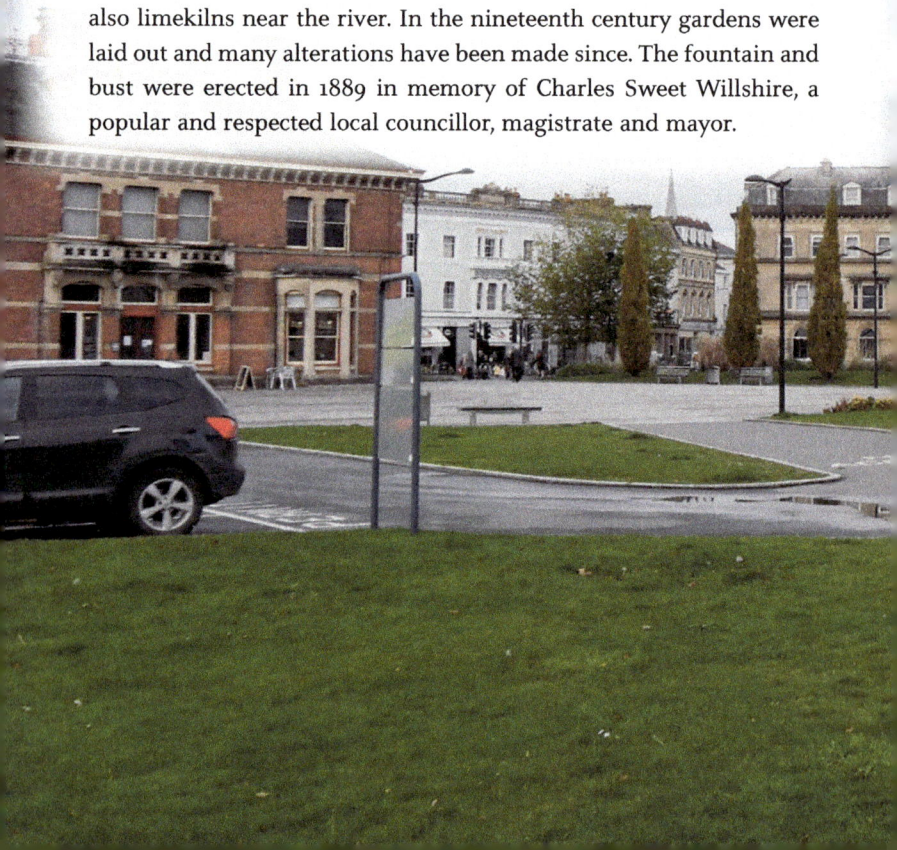

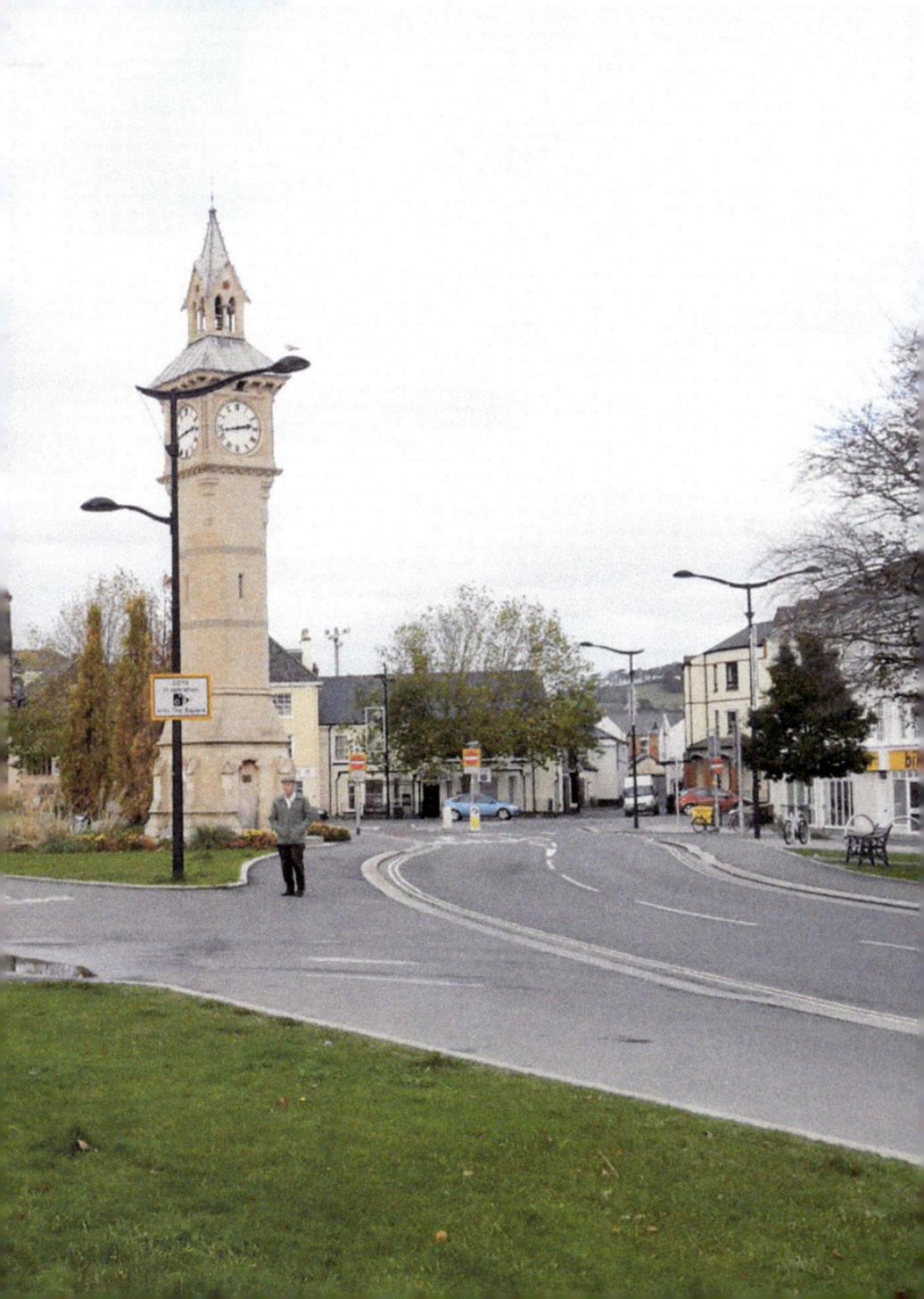

23. LITCHDON STREET

Cross The Square to the Albert Clock and begin walking down Litchdon Street. The photo is taken from just beyond the almshouses looking towards The Square. The Exeter Inn, now converted to residential accommodation, was a busy public house and coaching inn. Its name derives from its position on what was the main road to Exeter. Just beyond the inn can be glimpsed the Brannam's Pottery building, constructed in 1886 at the height of its success, but now just a façade with new occupiers.

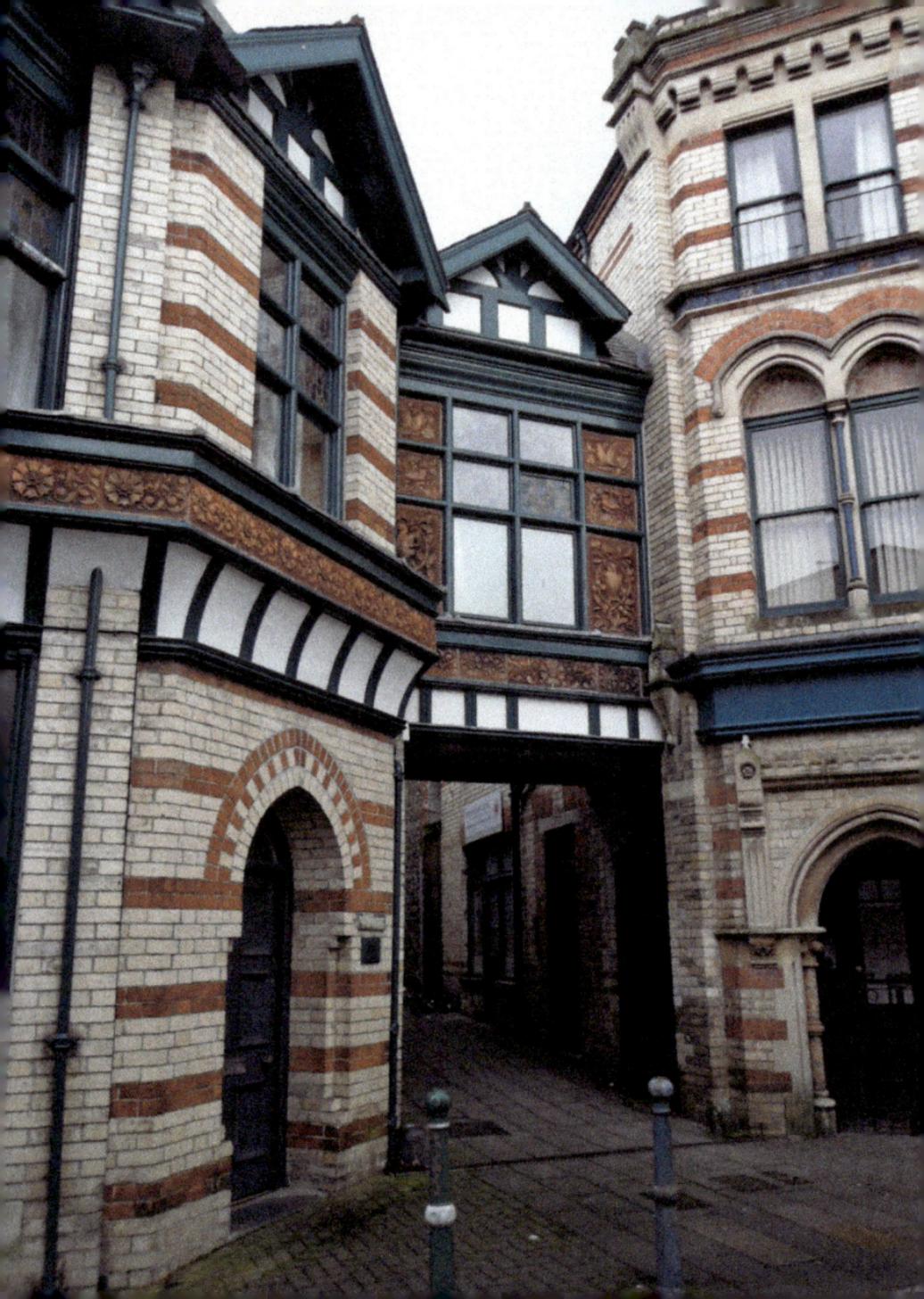

24. BRANNAM'S POTTERY

Continue along Litchdon Street and you will come to the old Brannam's Pottery building on your left. There was a working pottery here from at least 1830 and probably much earlier. Thomas Brannam bought the business in the 1850s and his son, C. H. Brannam, commissioned local architect W. S. Oliver to build a new showroom with family accommodation. This was completed in 1886 with a second building for manufacturing the pottery added the following year. Thomas Brannam had concentrated on domestic earthenware and had exhibited at the Great Exhibition of 1851 when some of his sgraffito ware had been praised by Prince Albert.

25. PENROSE ALMSHOUSES

Continue walking along Litchdon Street for another 80 yards or so, until you come to Penrose Almshouses. Easily identifiable, these almshouses were erected in 1627 in accordance with the bequest of John Penrose, one of the wealthy merchants who lived in Barnstaple around that time. Although restored and modernised over the years, their appearance has changed very little. Originally twenty dwellings for two people, the colonnade is framed with granite pillars with a chapel at one end and a meeting room at the other.

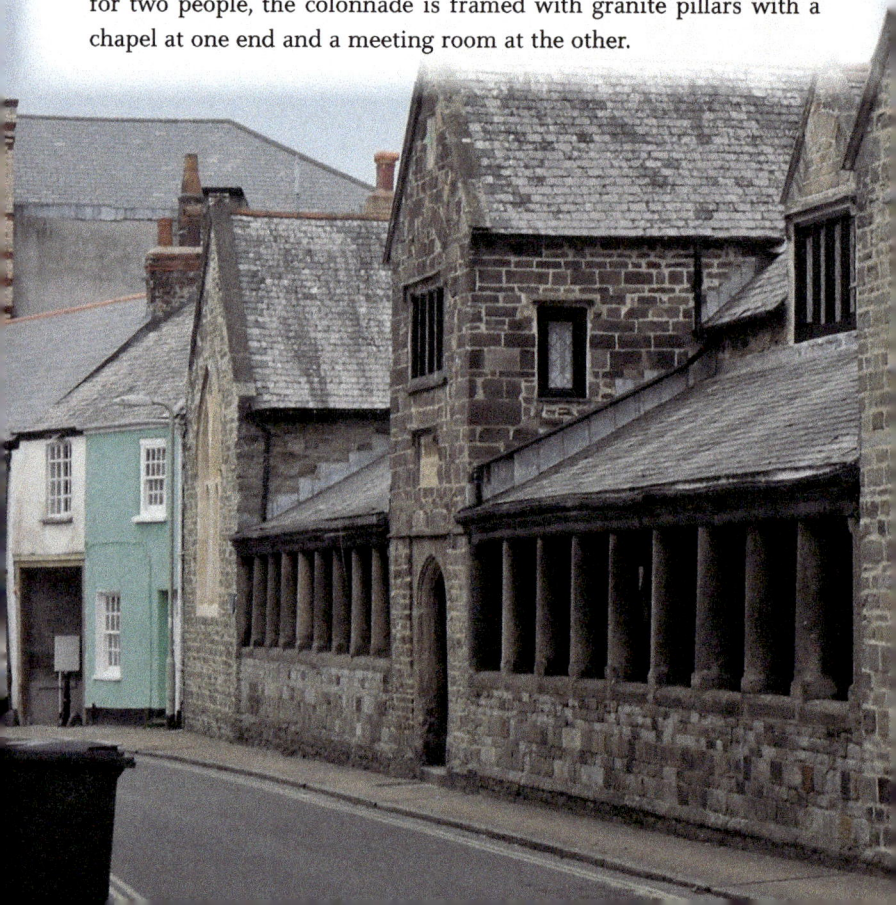

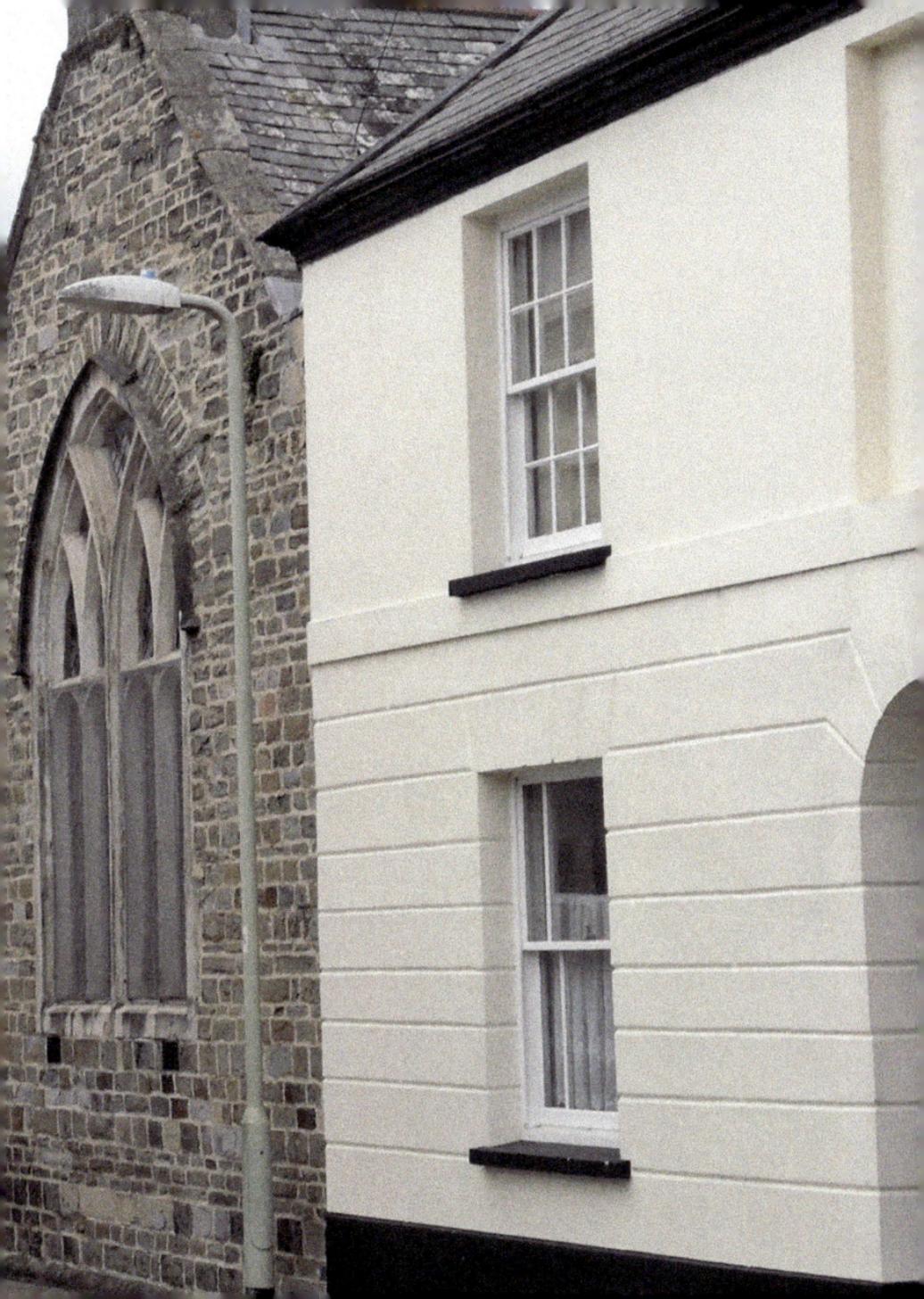

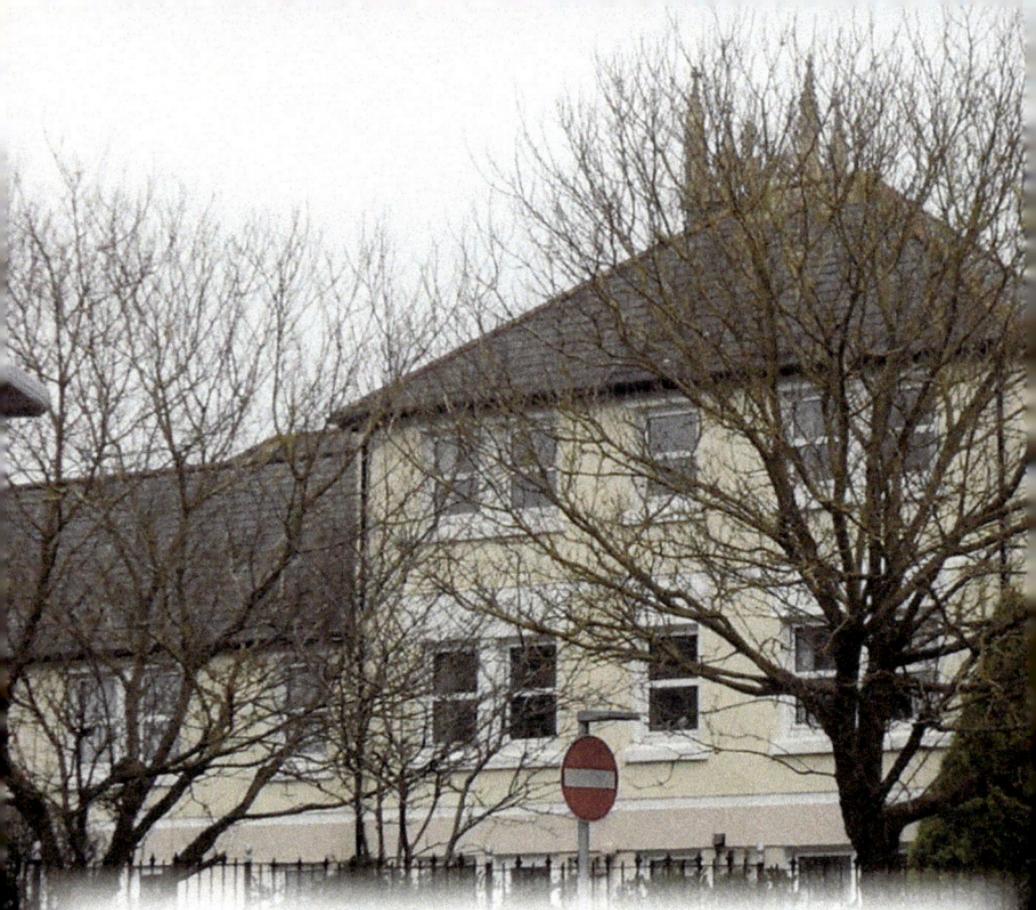

26. NORTH DEVON INFIRMARY I

Continue along Litchdon Street until you come to the junction with Barbican Terrace. Keep to your right. On your left is the large white building called Barum Court – a sheltered housing complex. It is built on the site of the North Devon Infirmary. Built by public subscription, the site was acquired in 1825 and the twenty-bed hospital opened to its first patients the following year. In 1828 a wing was added for 'offensive or infectious patients' with further wings added later. It closed in 1978 upon completion of the North Devon District Hospital. The buildings were demolished and the Barum Court flats built on the site.

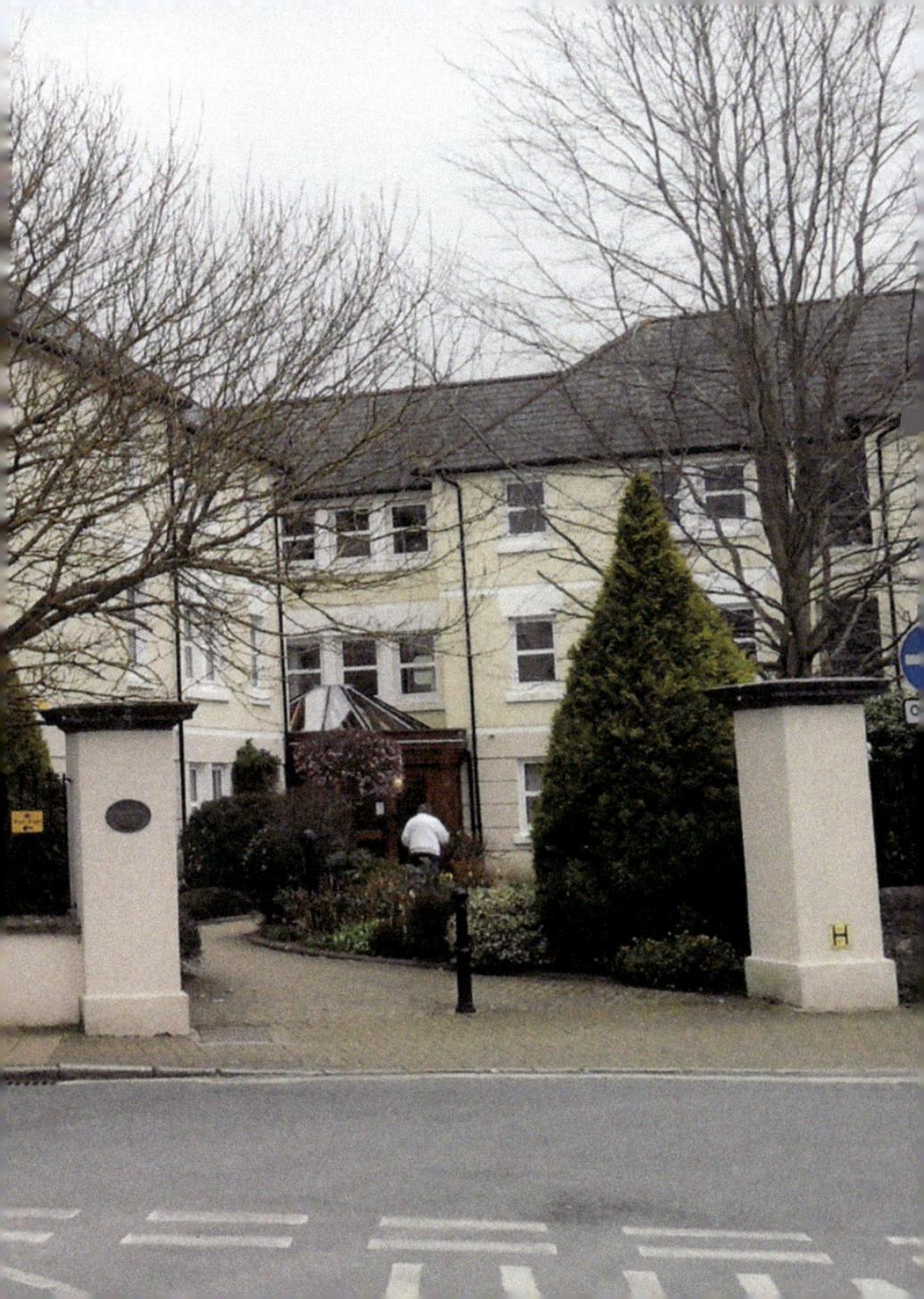

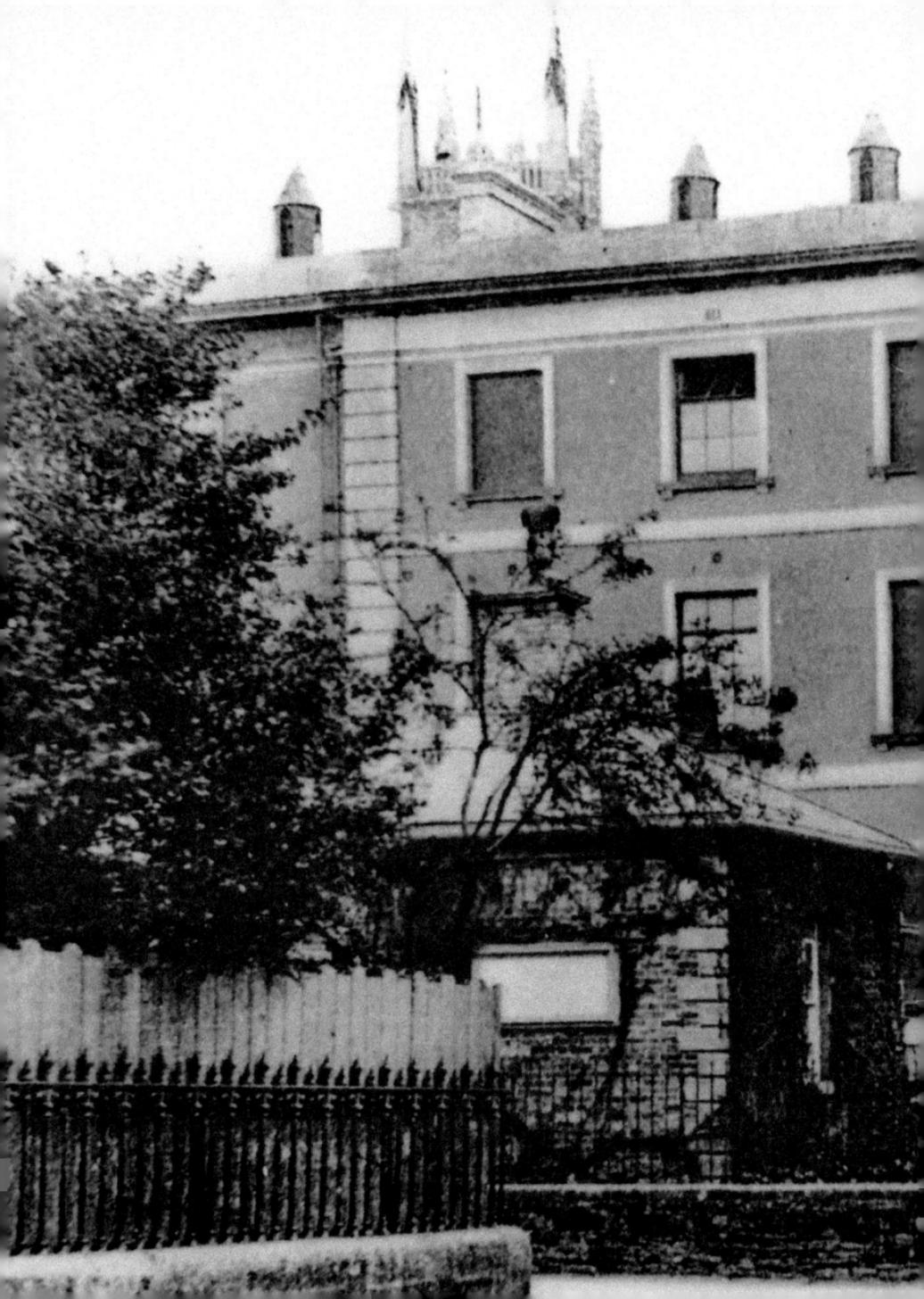

27. NORTH DEVON INFIRMARY II

In 1825 this site was meadow. It was then bought by the council as it was an ideal location for the new infirmary. Earl Fortescue, who was also the principal contributor, laid the foundation stone in a grand ceremony attended by all the council. In this earlier photograph you will notice the tower of Holy Trinity Church, which is now almost hidden by the trees. After the site was cleared the ground was not allowed to be built on for a number of years. This was to ensure no germs from the hospital had survived in the soil.

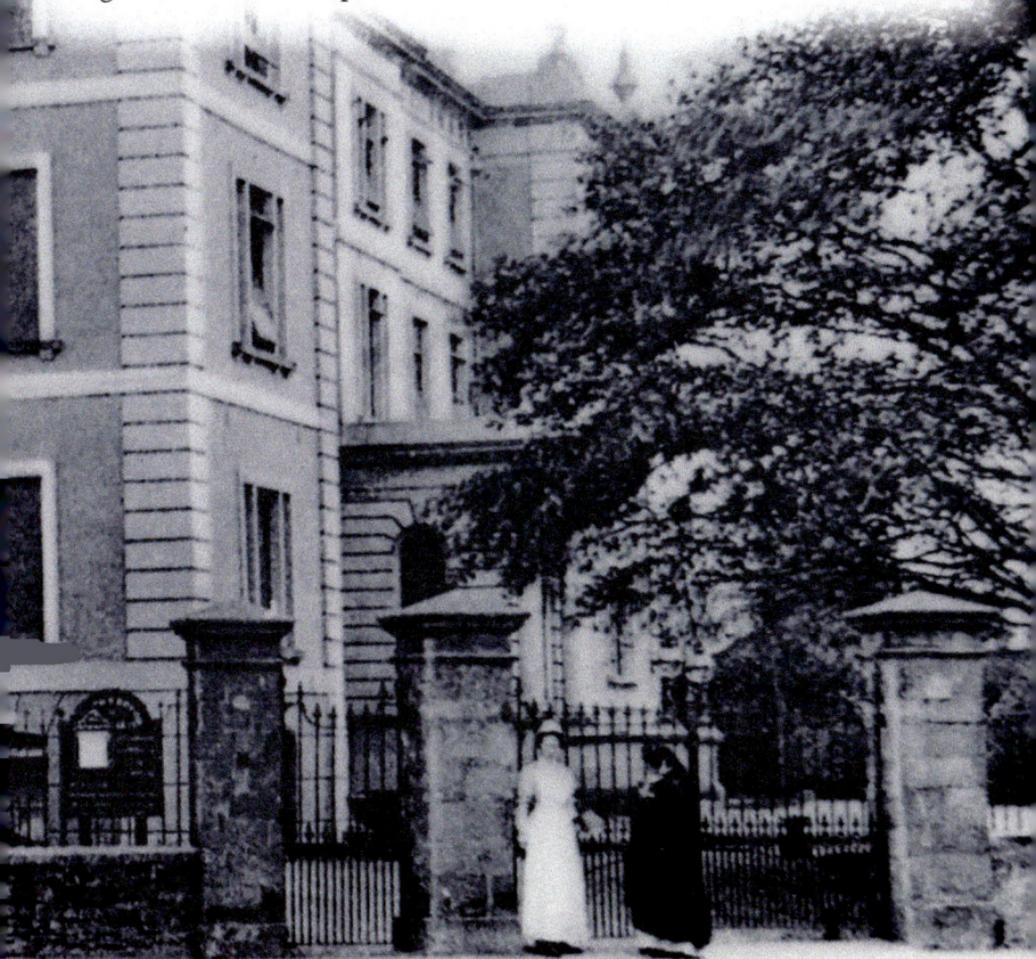

28. ROCK PARK

Keeping to the right, continue along Litchdon Street until you join Taw Vale. Looking across the road you will see the war memorial at the entrance to Rock Park. Erected in 1922, it records the deaths in active service of 227 Barnstaple men during the First World War. Rock Park was opened in 1879 when William Frederick Rock, the town's great Victorian benefactor, bought land to add to the existing area called Chanter's Green, formerly a marsh called Goose-lease. There was originally a tree at the entrance to the park, but in 1912 the town council decided to replace it with a rockery and flower bed, which can be seen in these photos.

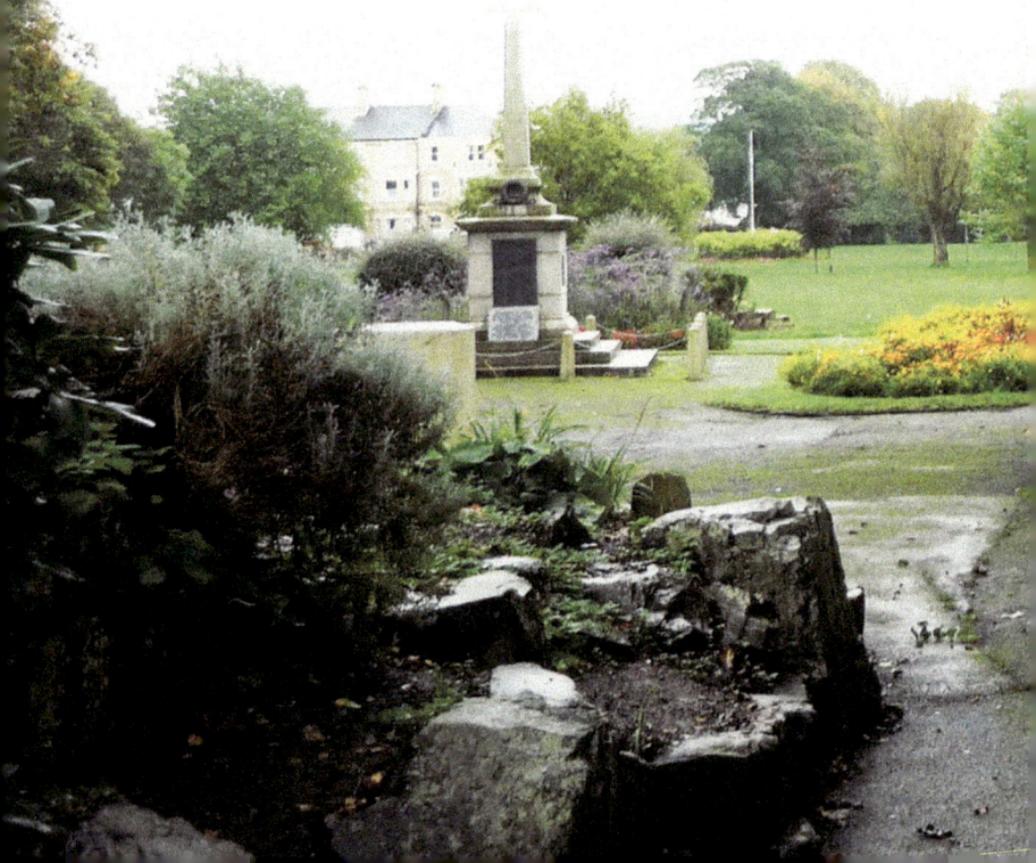

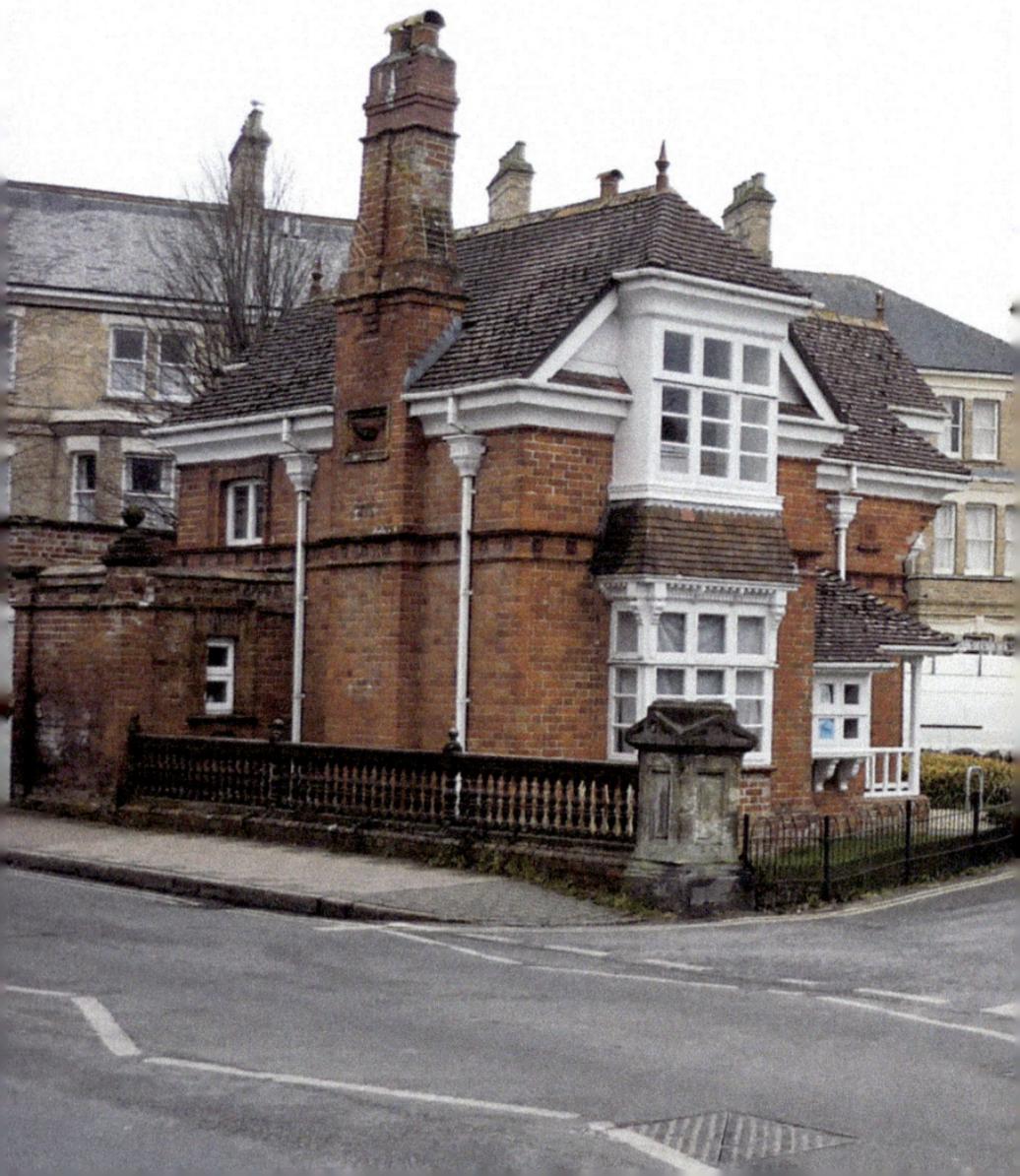

29. ROCK PARK LODGE

Cross over and turn left, passing the Park Hotel. On your right, you will see the pretty Edwardian Rock Park Lodge at the Newport Road entrance to the park. It was intended for living accommodation for the park-keeper and was paid for by John Payne, the business partner and brother-in-law of William Rock. The furnishings were provided by Prudence Payne, Mr Rock's sister. The lodge has recently been renovated and the scene is very similar today, although the pillars no longer support lamps, having been replaced by modern lighting.

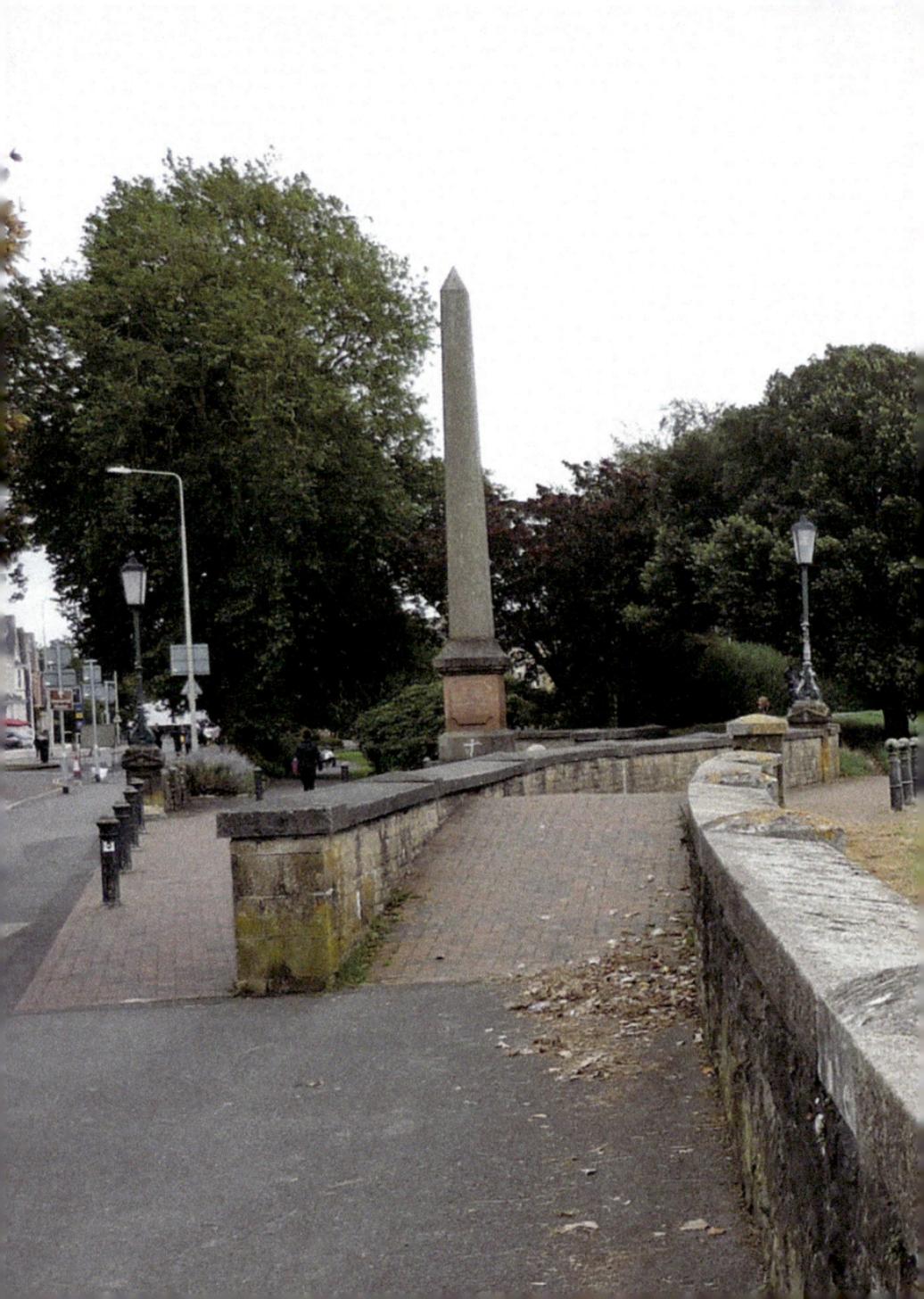

30. TAW VALE I

At this stage in the walk you may choose to explore Rock Park further. However, to continue with the history tour you will need to turn around and walk back down the fine Victorian thoroughfare of Taw Vale Parade. Prior to 1846, when Taw Vale was created, there were no buildings between the back of Litchdon Street and the river. There was a low river wall, but the river area was considered rough and unattractive. Litchdon Street was also the main road to Newport at that point and it was considered that a better approach was needed.

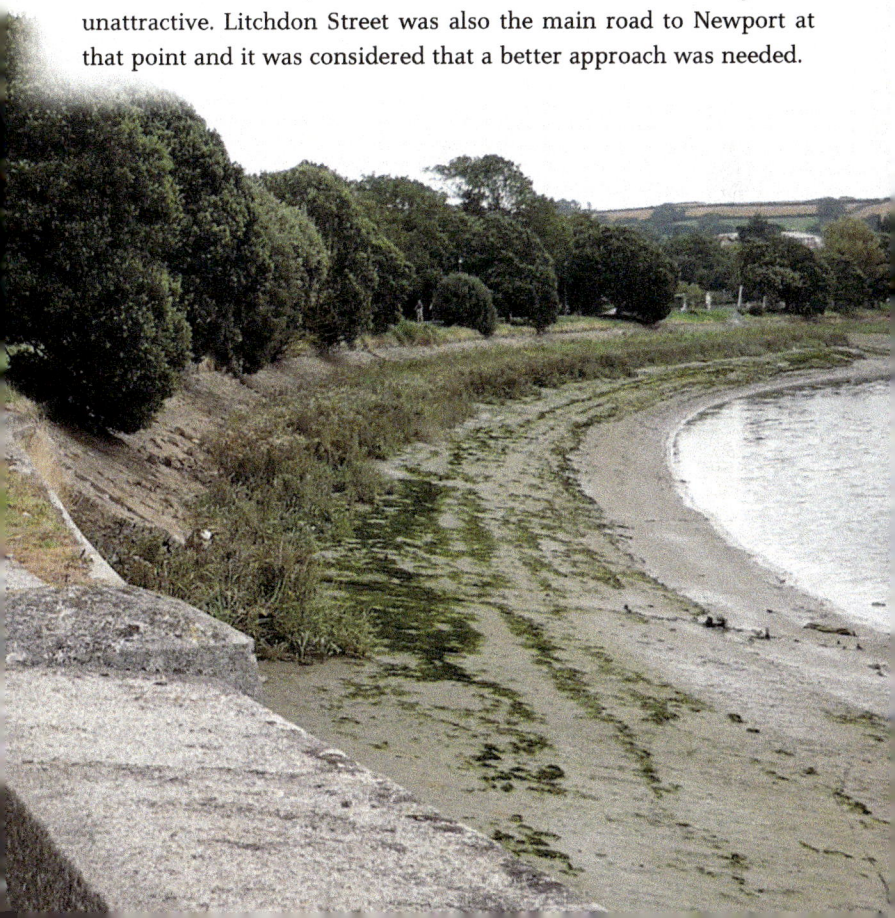

31. TAW VALE II

To improve the appearance of the town from the riverside, Taw Vale Parade – originally called New Road – proved to be a major undertaking as the entire riverbank had to be raised. Shortly after construction, a grand terrace of houses was built to complete the effect. It is worth noting the elegant bases to the lamp posts. Shaped like dolphins, they were installed in 1888. Marked Coalbrookdale, they were made at Abraham Darby's foundry in Shropshire.

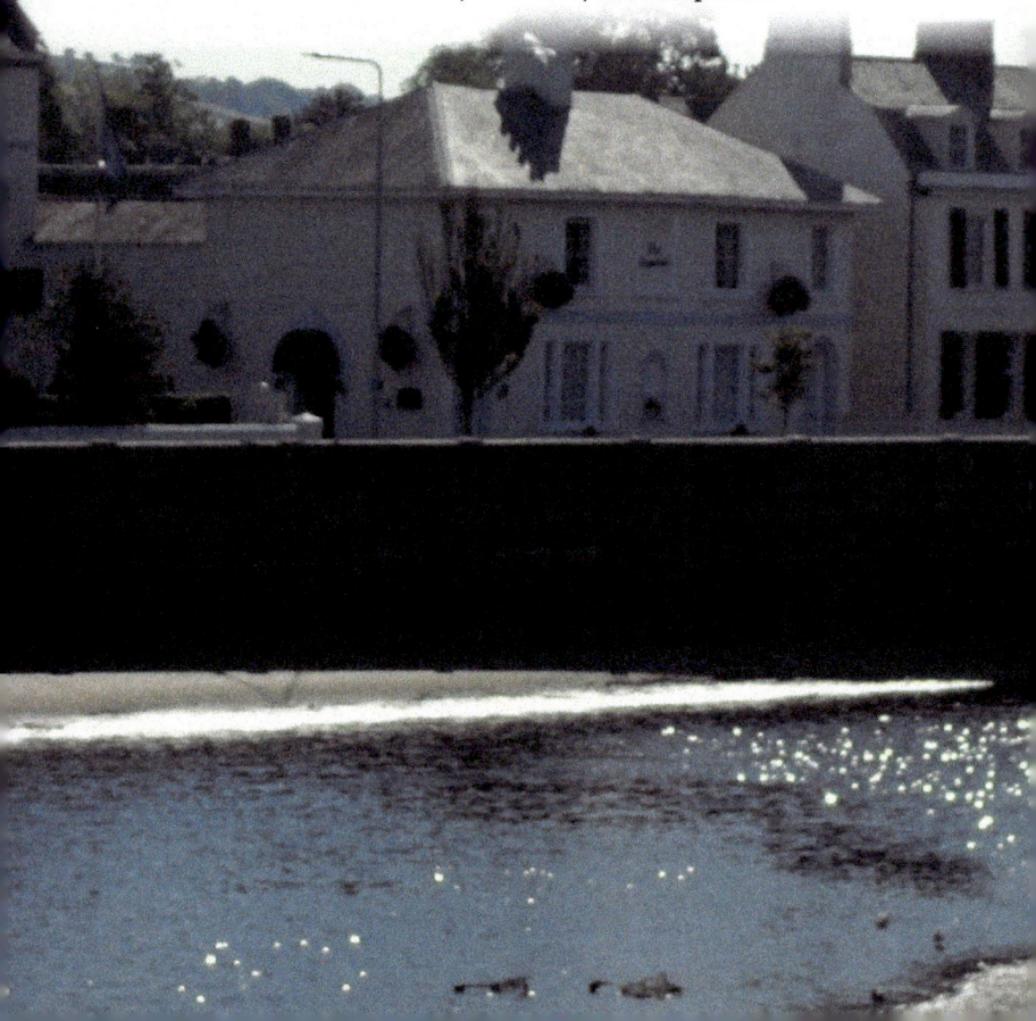

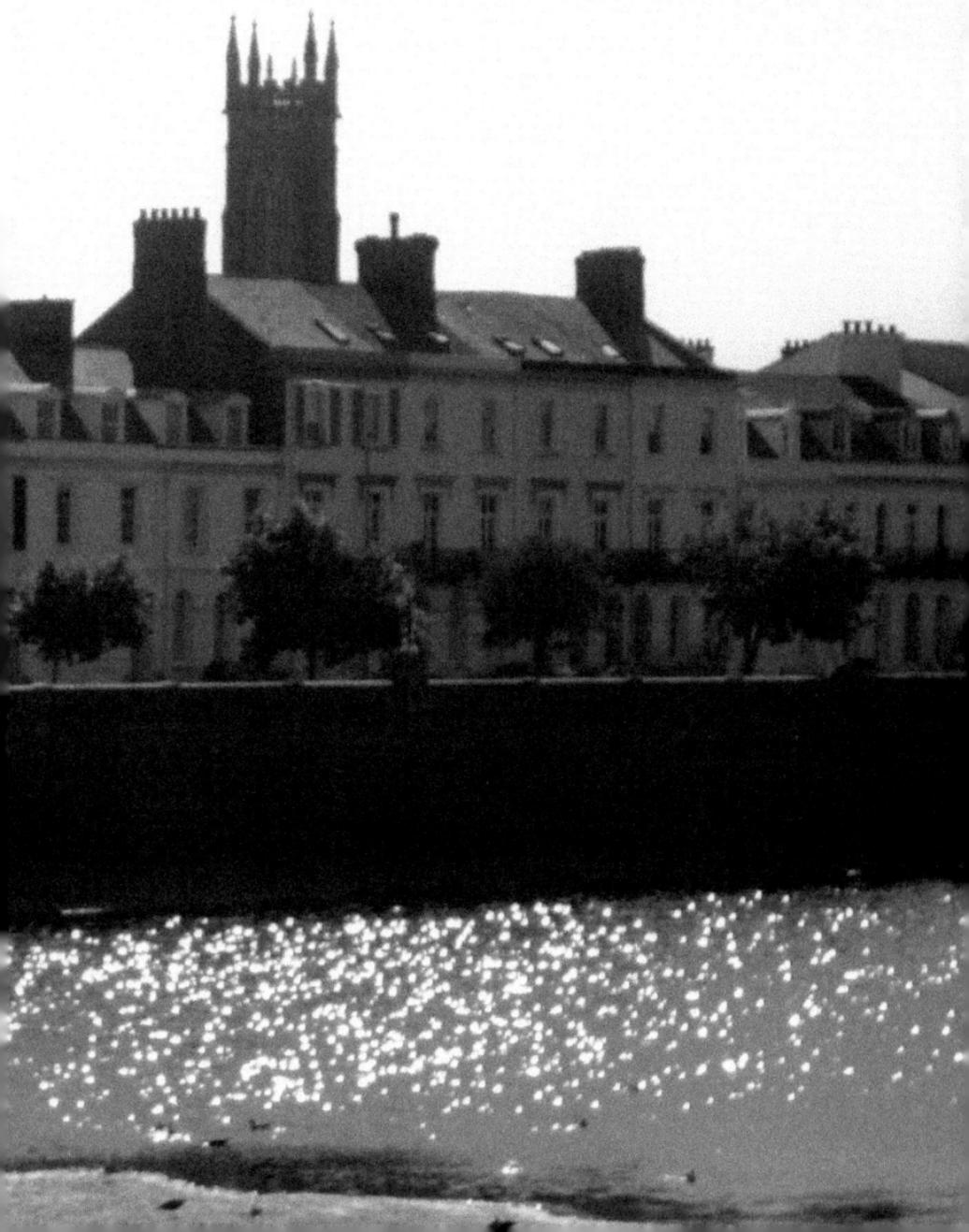

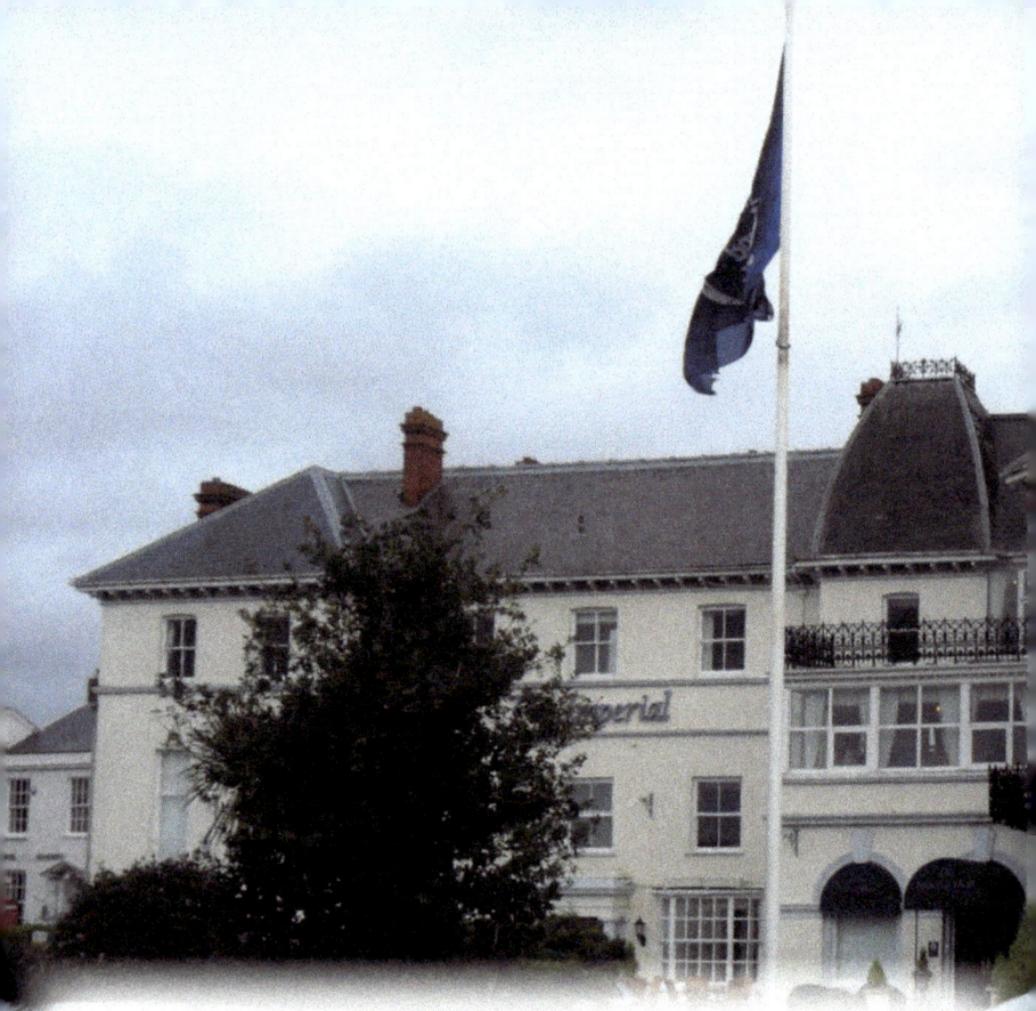

32. IMPERIAL HOTEL

As you reach the end of Taw Vale Parade on your right you will see the imposing Imperial Hotel. Built as a private house, it became a hotel in 1898 and was quickly enlarged. The original part of the building is to the left of the main entrance as you look at it. In 1905 the hotel had a royal visit when Princess Helena (third daughter of Queen Victoria) and her daughter stayed there. During their stay they also visited Brannam's Pottery and the Pannier Market.

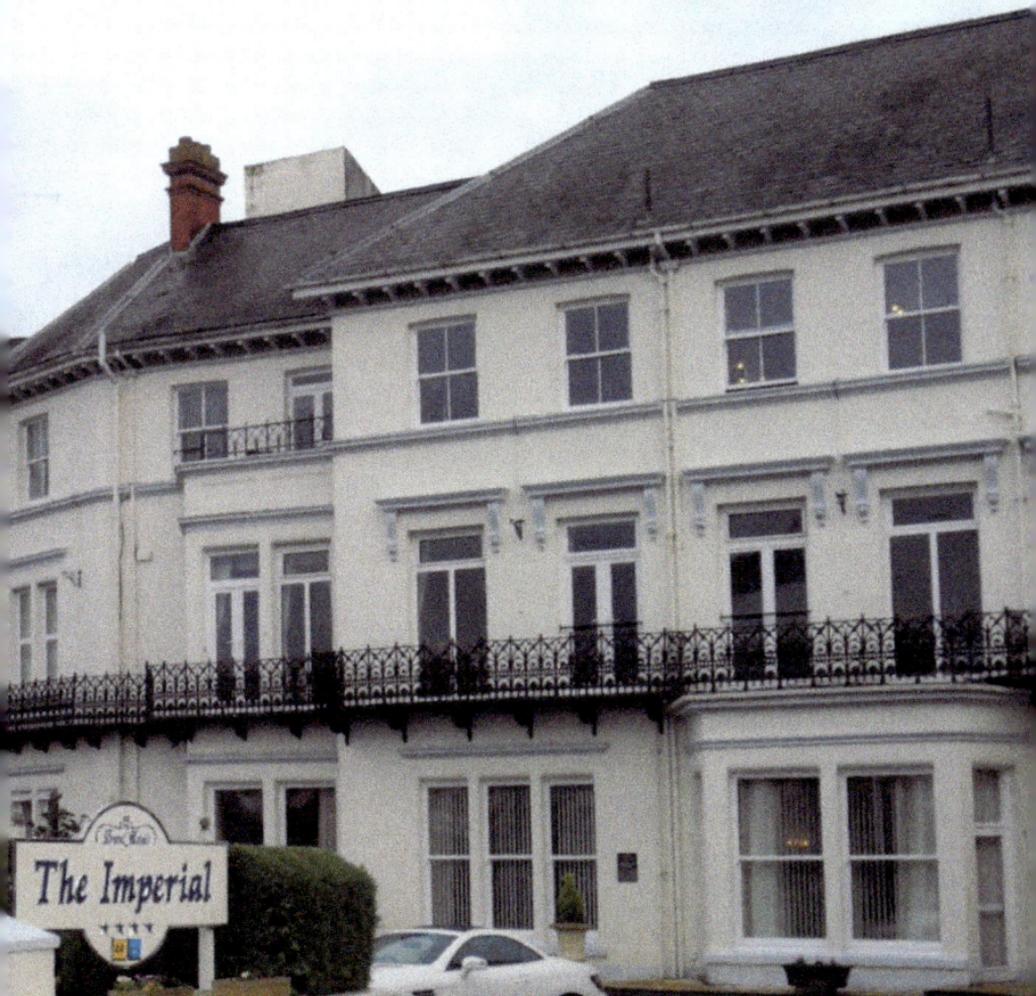

The Imperial

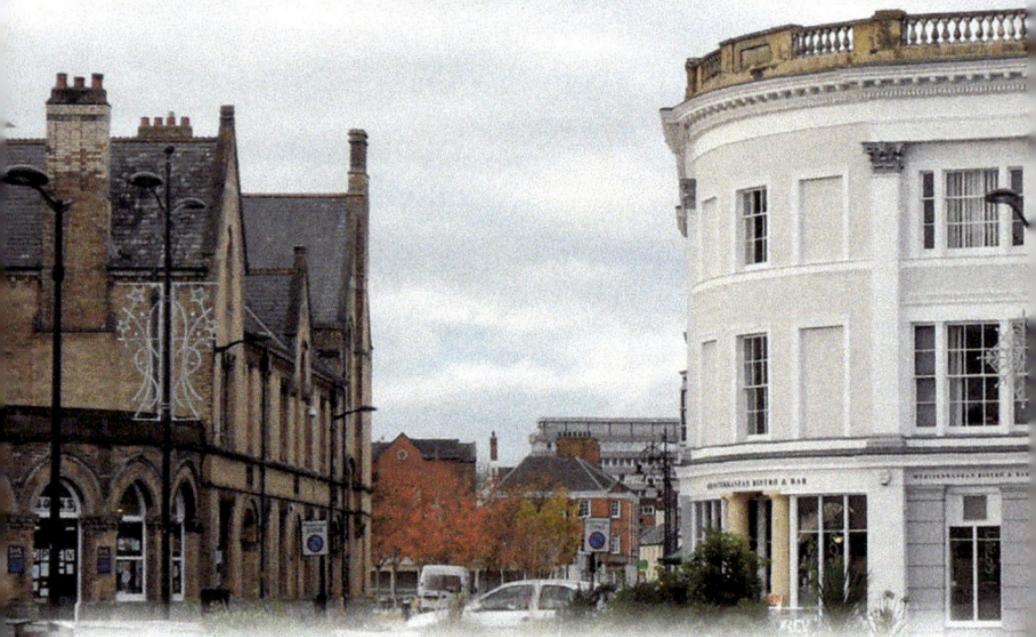

33. BRIDGE BUILDINGS AND BRIDGE CHAMBERS

Arriving back on The Square, stand with the clock tower behind you and note the two buildings either side of The Strand. Both buildings were designed by borough architect R. D. Gould, yet they show vastly different architectural styles. Bridge Buildings, on the right, was the first of Gould's many projects over his long career. Built in 1844, it is a fine example of the neoclassical style. Bridge Chambers, built only thirty years later, was typical of the newly fashionable Victorian Gothic style.

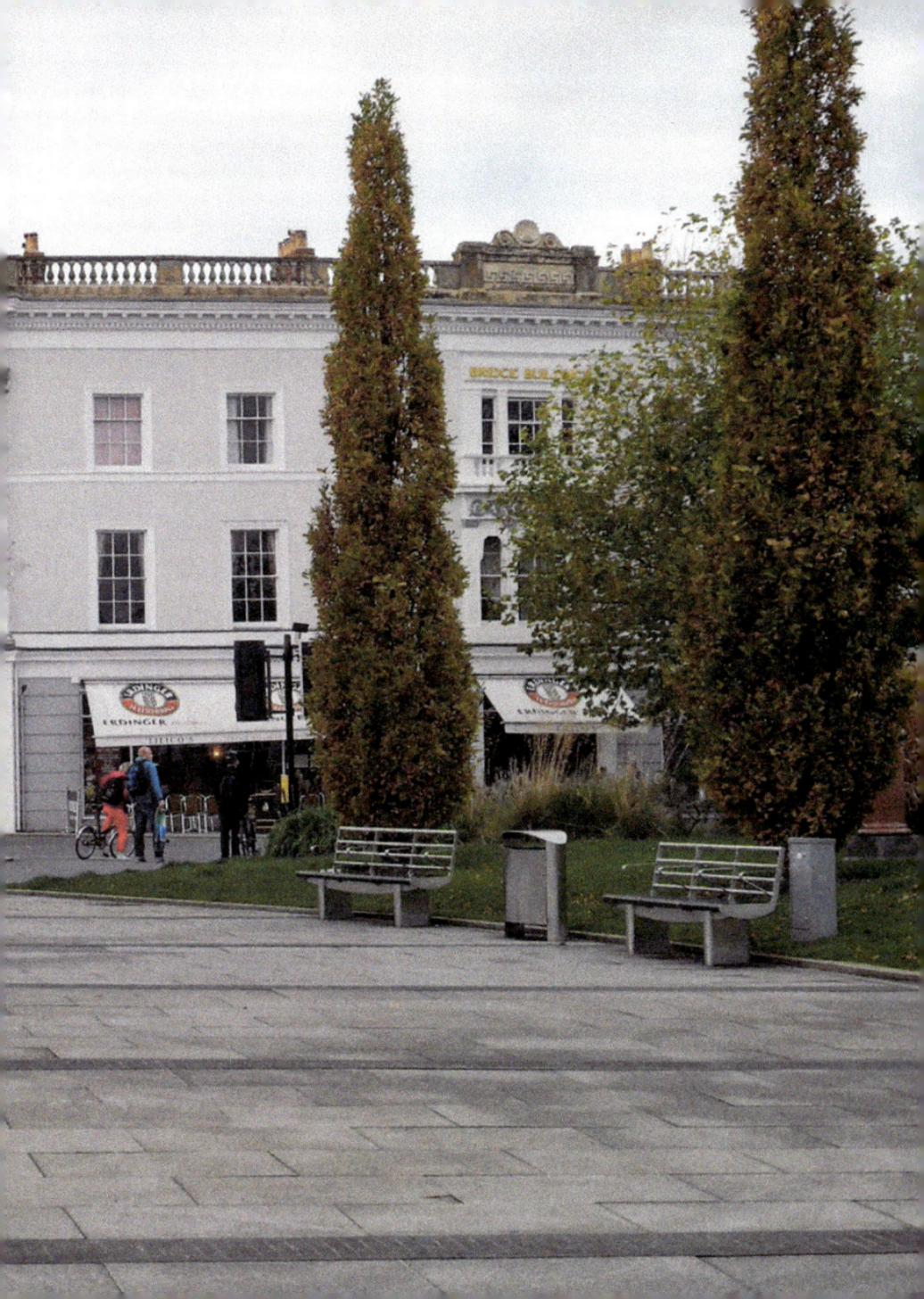

34. BRIDGE BUILDINGS

The older photo was taken in 1865 and shows The Square before the gardens were formally laid out later in the Victorian era. Until the eighteenth century this area was a marsh and causeways were needed to get from the end of the bridge to High Street and from Litchdon Street to the town. The photograph was taken nine years before Bridge Chambers was built and the houses which were knocked down for its construction can be see.

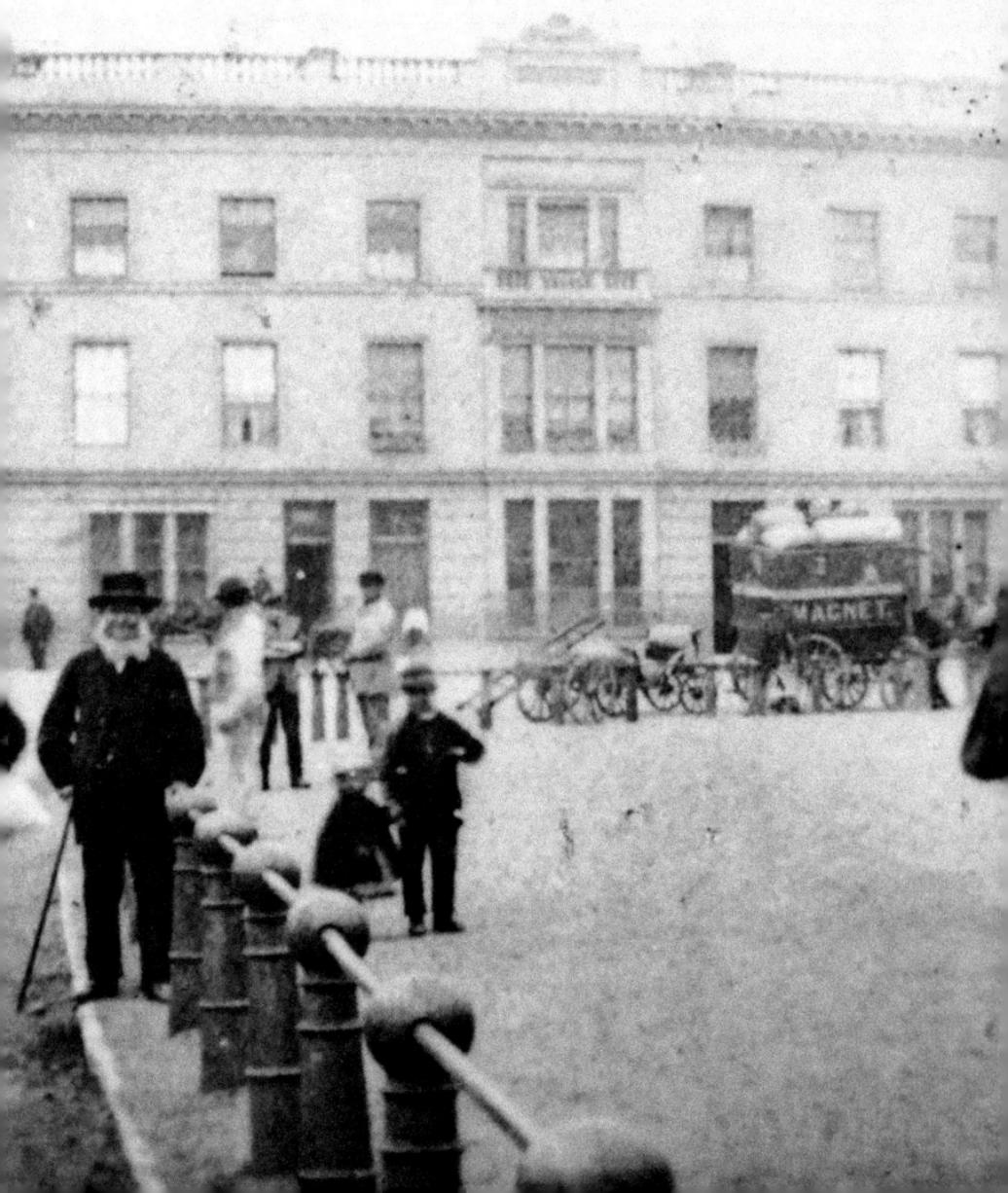

35. LONG BRIDGE

Walk across The Square passing the Museum of Barnstaple & North Devon on your left and cross the road to The Strand. Continue on past Bridge Chambers and as you look towards the River Taw you can see the Long Bridge. The exact age of the bridge is unknown, but its first recorded reference is in a document dated 1280. It was originally maintained by the Bridge Trust with the proceeds of money and property given for that purpose. This continued until the early 1960s when the Ministry of Transport took over responsibility. There have been many alterations and widenings over the centuries with the original width being just over 10 feet.

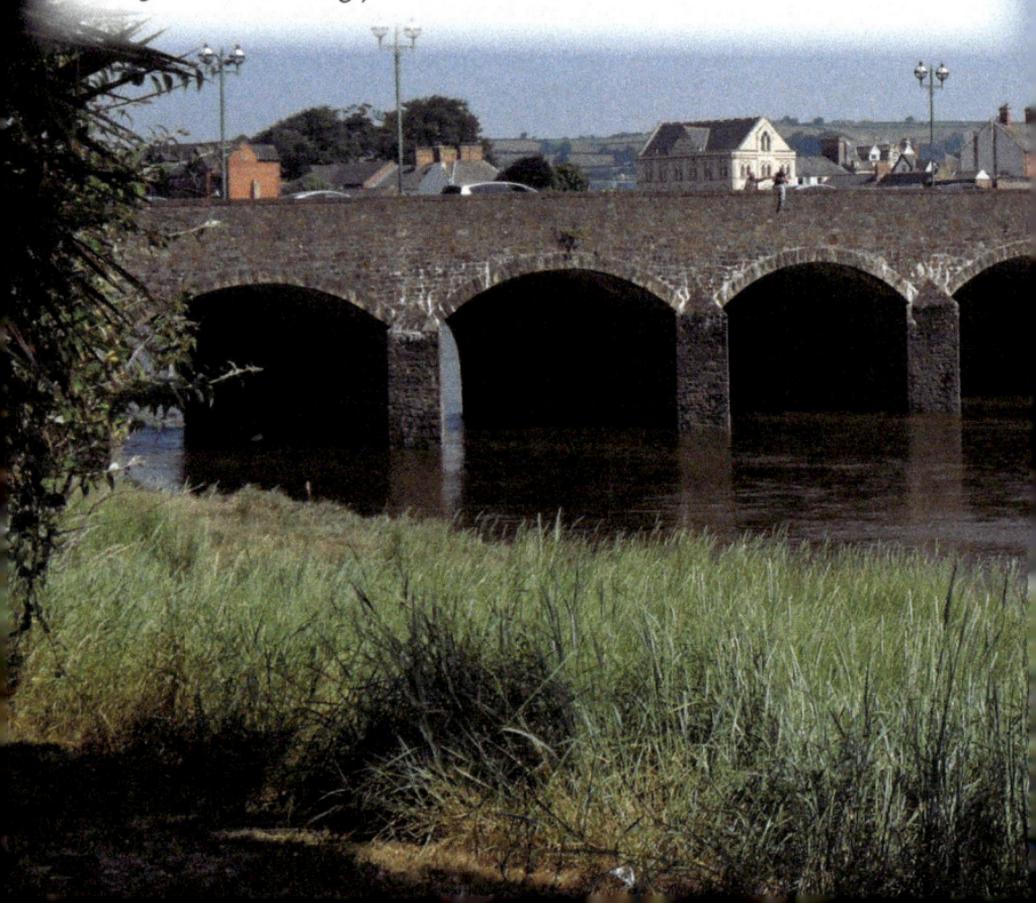

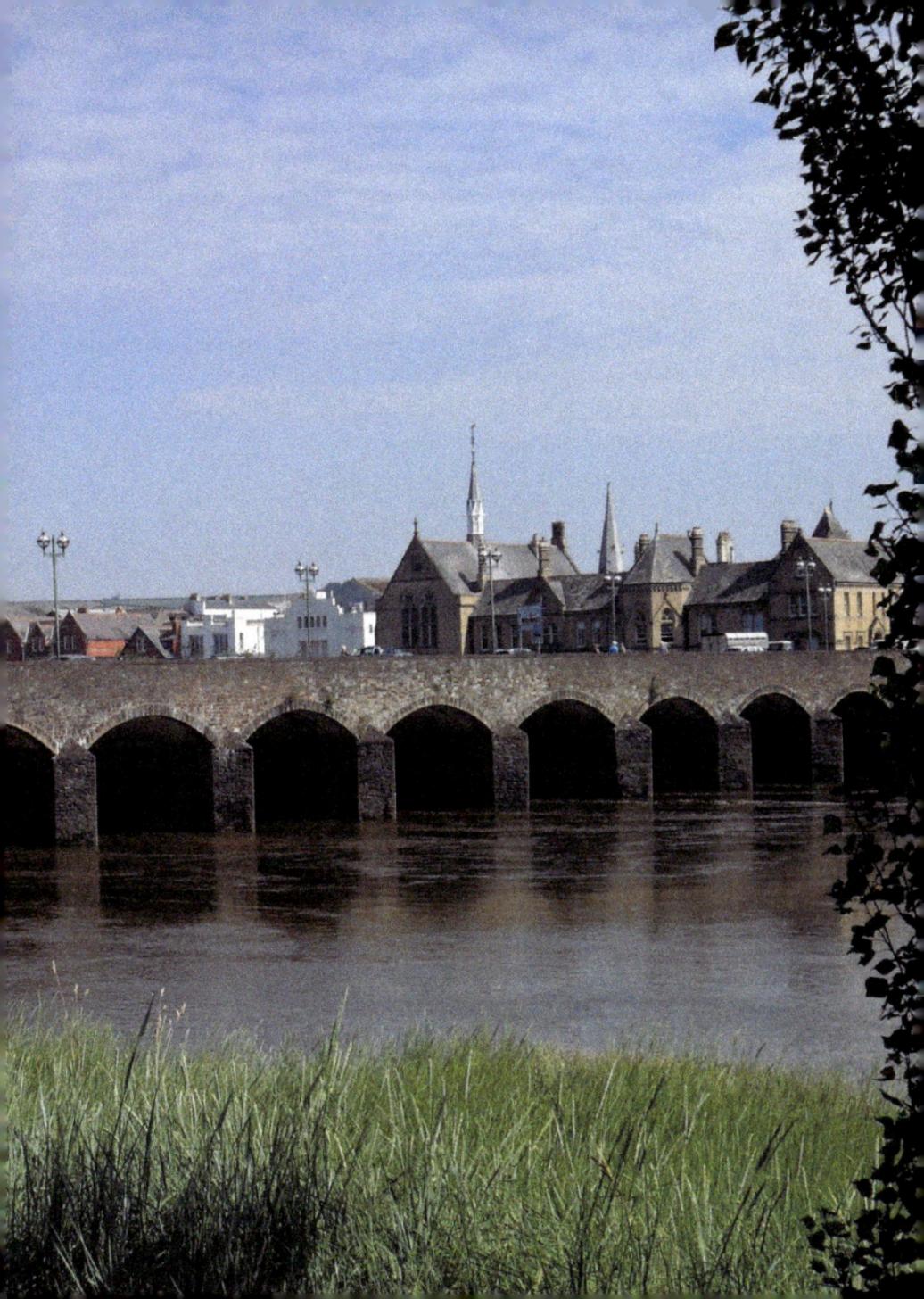

36. METAL RAILWAY BRIDGE

The old curved railway bridge is shown in this photo. Erected in 1874, the bridge carried trains from Junction station across the river and eventually to Ilfracombe. It was 213 yards long and curved through 90 degrees. It comprised of fifteen pairs of main girders, each one 40 feet in length, with the weight of the bridge resting on wrought-iron piers sunk into the riverbed and filled with concrete. At its construction it had the tightest and shortest curve for a railway bridge in the world. Demolished in 1977, the iron struts where it was attached to the river wall can still be seen.

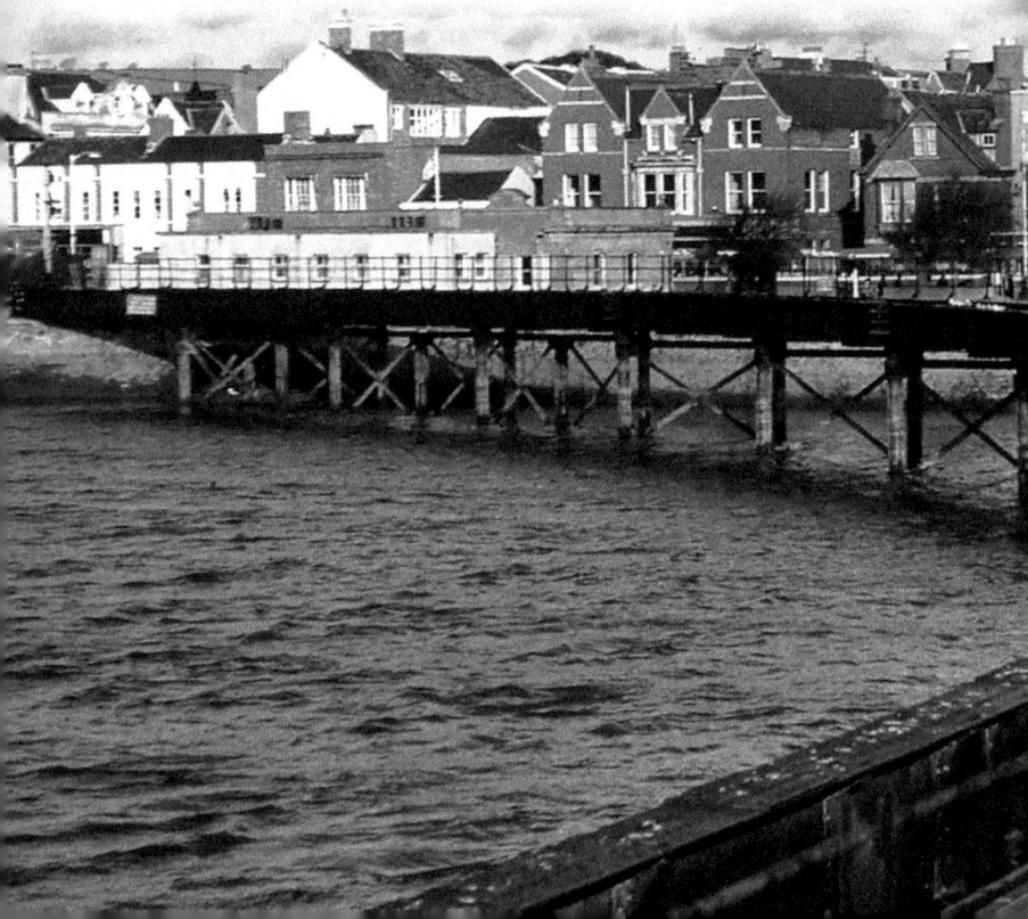

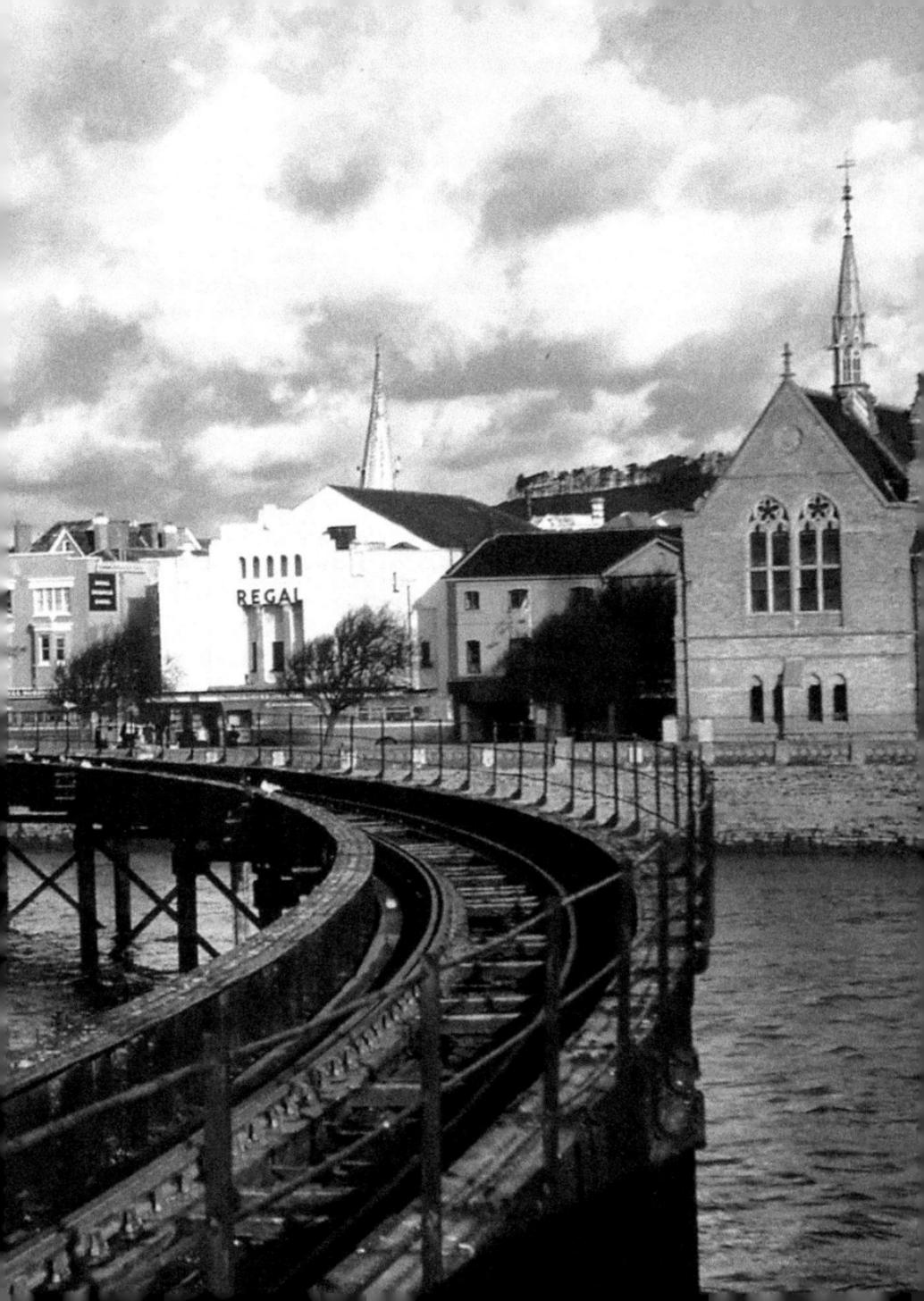

37. THE STRAND I

Continue to walk along The Strand. The name 'Strand' refers to a shore, in this case the shore of the River Taw where Barnstaple was established in the ninth century. For many centuries the town was an important port and The Strand would have been as busy as the High Street. The older photo dates from around 1900 and looks very different from the view today. The Bell Hotel can just be seen on the right and the tall building in the centre was the Gentlemen's Club. The next building along on the corner of Cross Street was the Queen Anne's Temperance Hotel and still stands today.

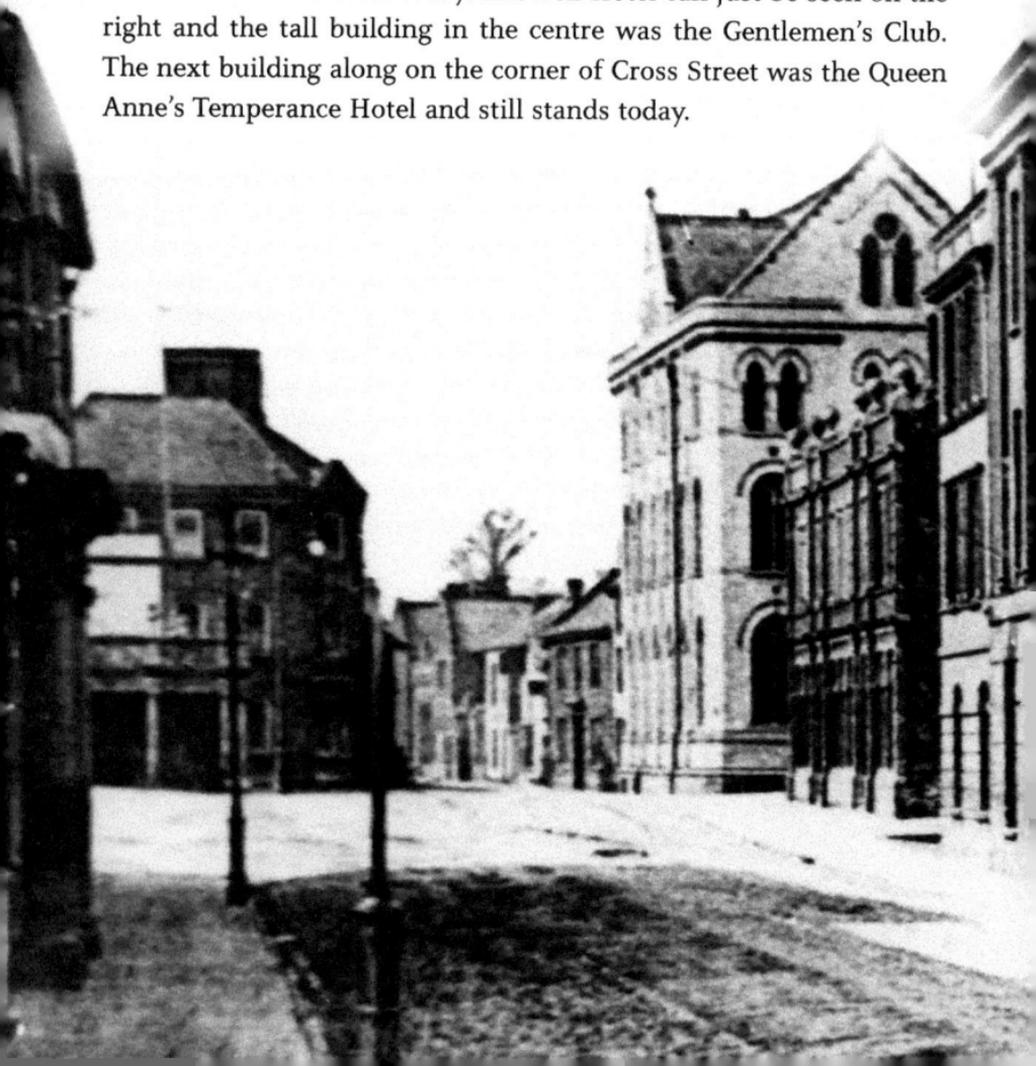

38. THE STRAND II

In this recent photograph of The Strand the Congregational School Rooms can still be seen through the relatively recently planted trees, together with the Old Custom House. However, the Bell Hotel and Gentlemen's Club have now gone. The town's fish market once stood on this site until it was demolished as part of the alterations to The Strand when the railway line was laid in 1873.

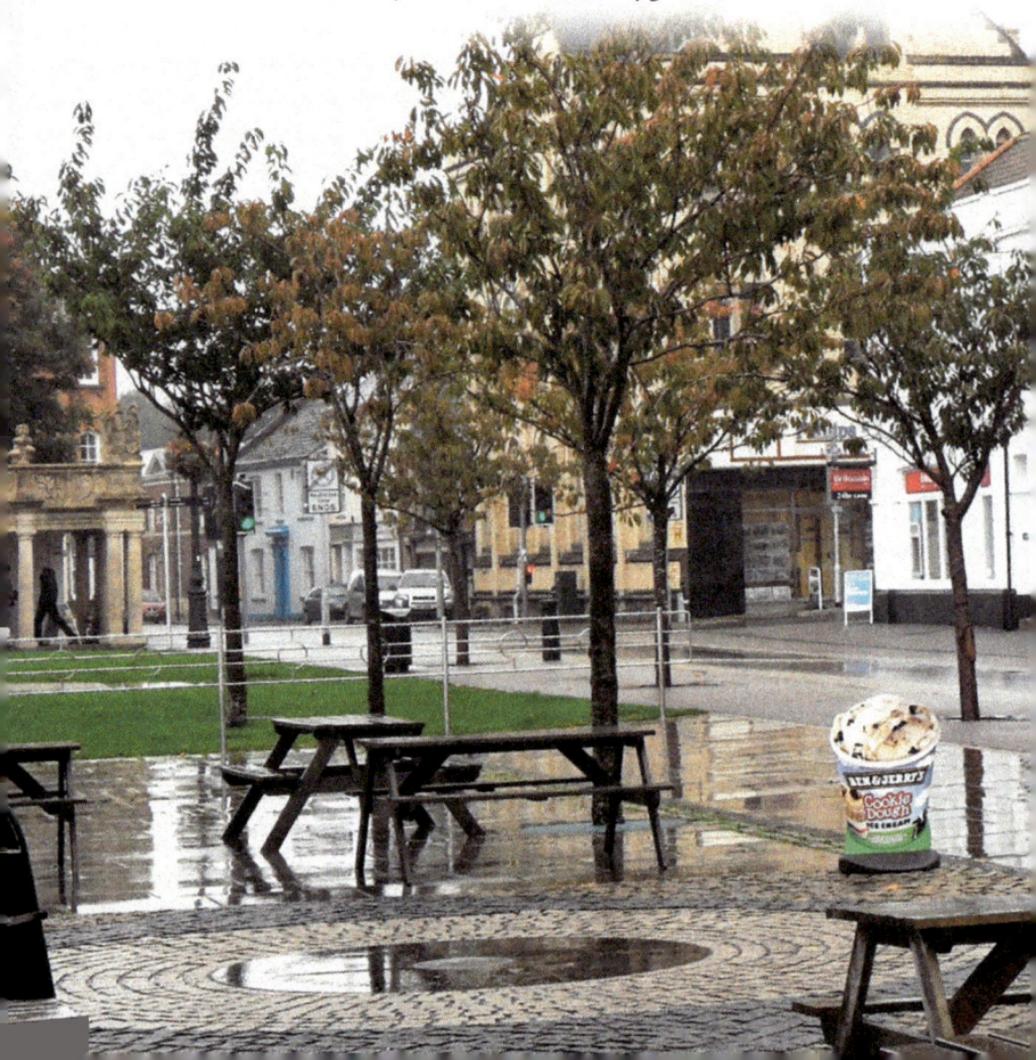

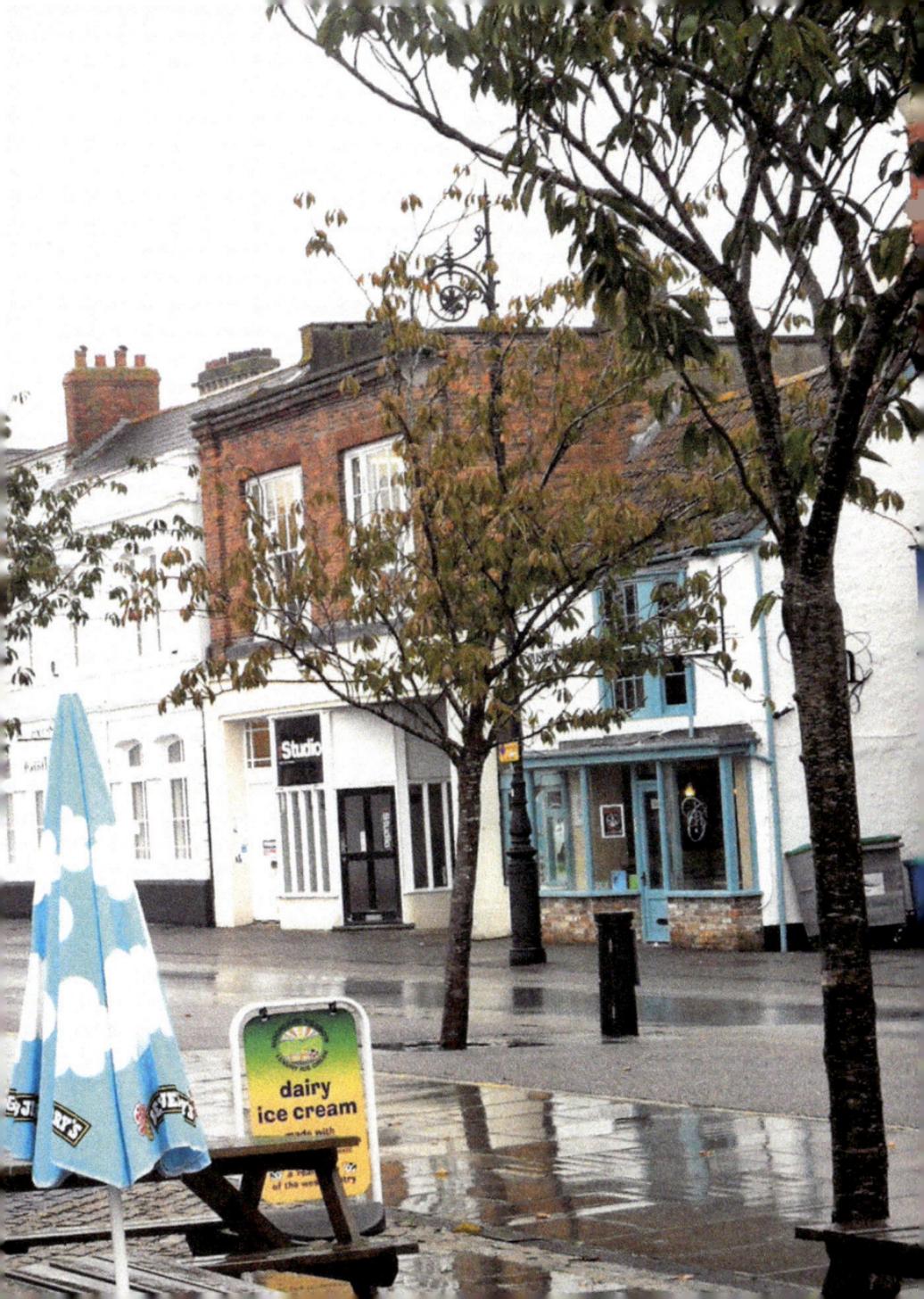

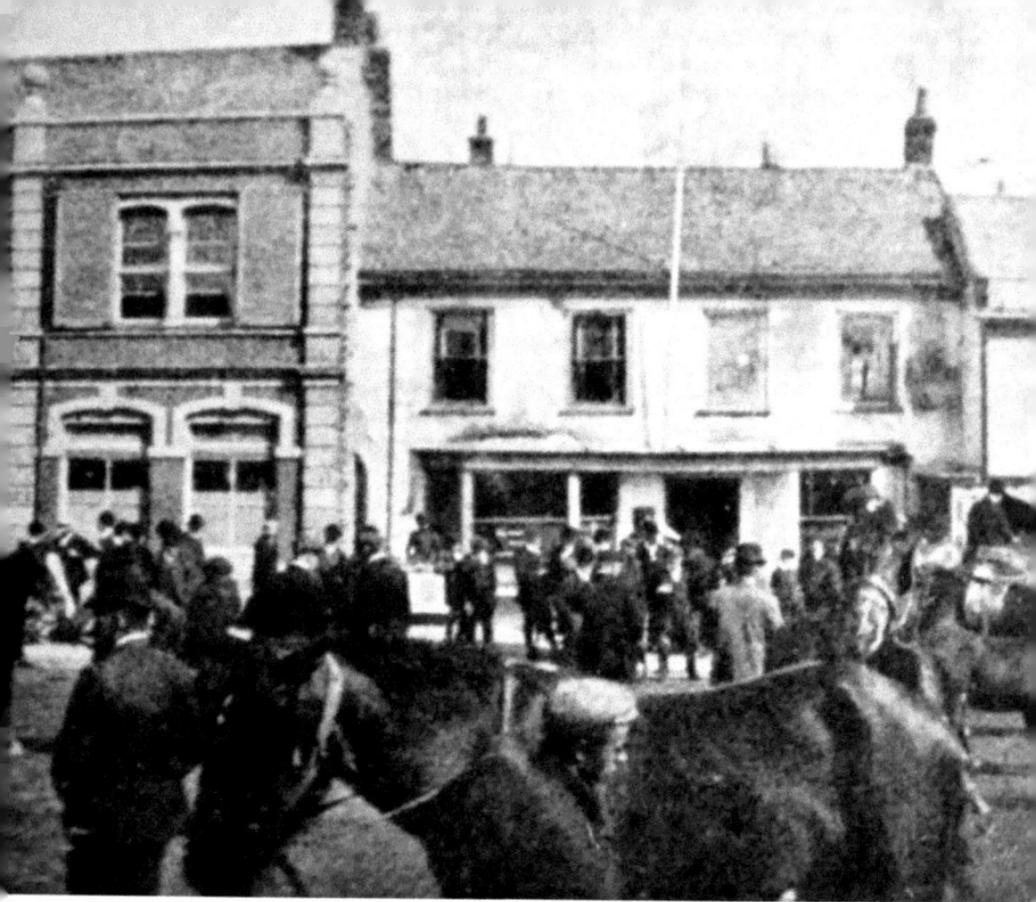

39. THE STRAND III

Another view of The Strand is revealed in this wonderful photo from 1904 and shows the area being used for the Horse Fair, an annual event held as part of the town's ancient fair every September. Although the trading days of the fair no longer take place, the funfair is still held across the river with the ceremony of the Calling of the Fair taking place in Barnstaple's current Guildhall. The building in the middle, now a restaurant called the Old Custom House, has been through many changes. As the modern name suggests, in the seventeenth century it was a custom house.

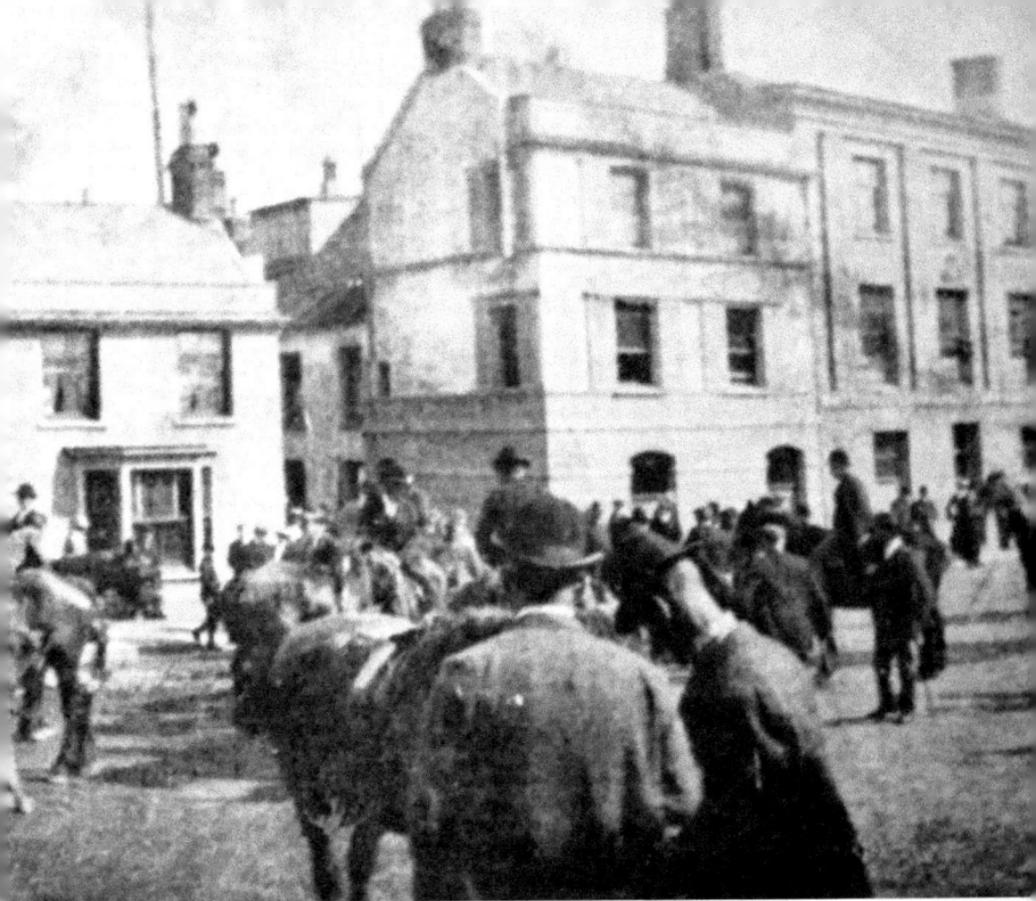

40. THE STRAND IV

The same view taken today is still recognisable although the area has seen many changes. The two buildings either side of the Old Custom House have gone and have been replaced with later buildings. In the forefront of the modern photo is a corner of the Millennium Mosaic, constructed in 2000 as part of the millennium celebrations. The mosaic, which tells the history of the town in mosaic panels, is set in a sunken area laid out on the site of the Great Quay.

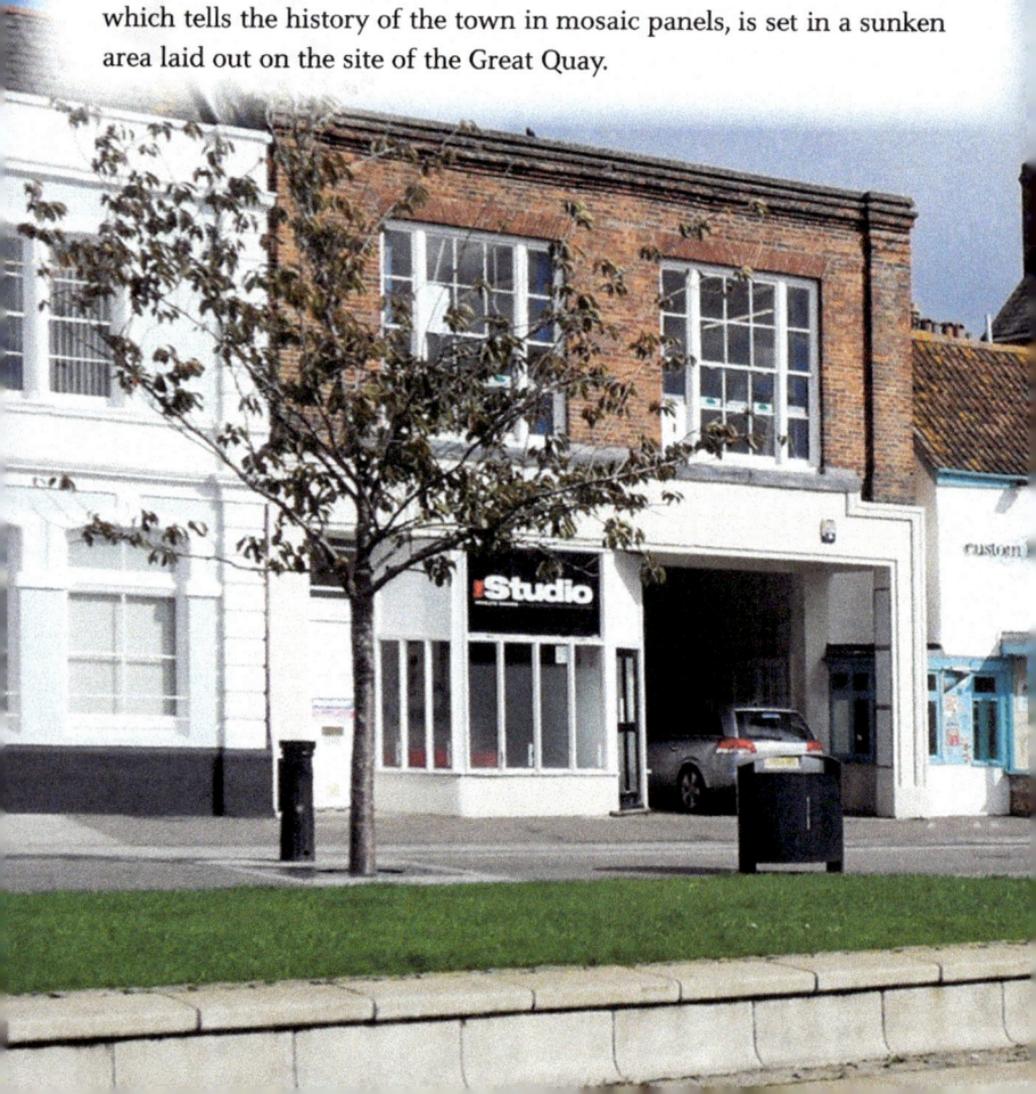

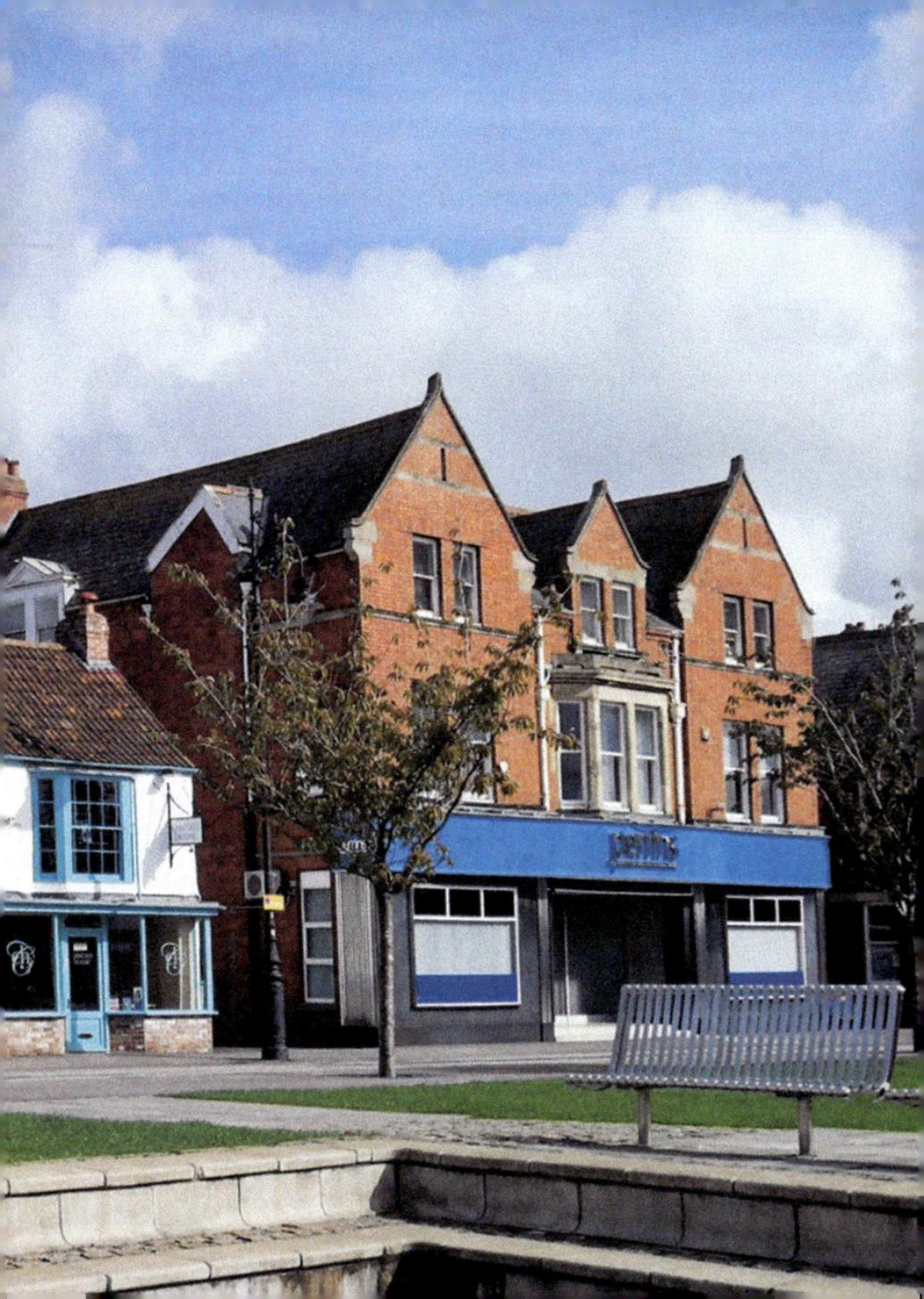

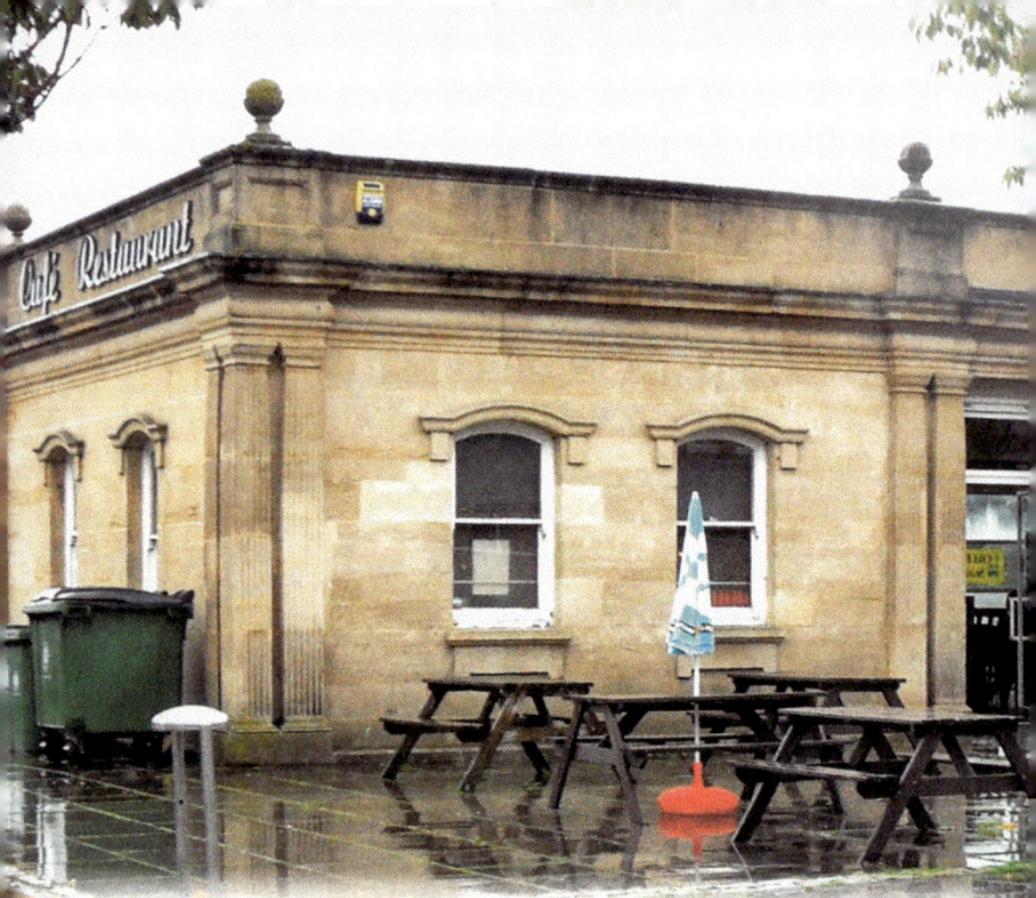

41. OLD BUS STATION

As you walk along The Strand you will see the old bus station building, now a café called The Tea on the Taw. This area has seen much change over the centuries and was once the busiest part of town. The building dates from 1922 when there were major alterations to this area. It was built as the bus station and replaced the Quay railway station on the same site. Quay station was erected in 1874 when the trains were extended across the river, but it soon became too small and a new station was built further along. It continued in use until a new bus station was built across town in 2000.

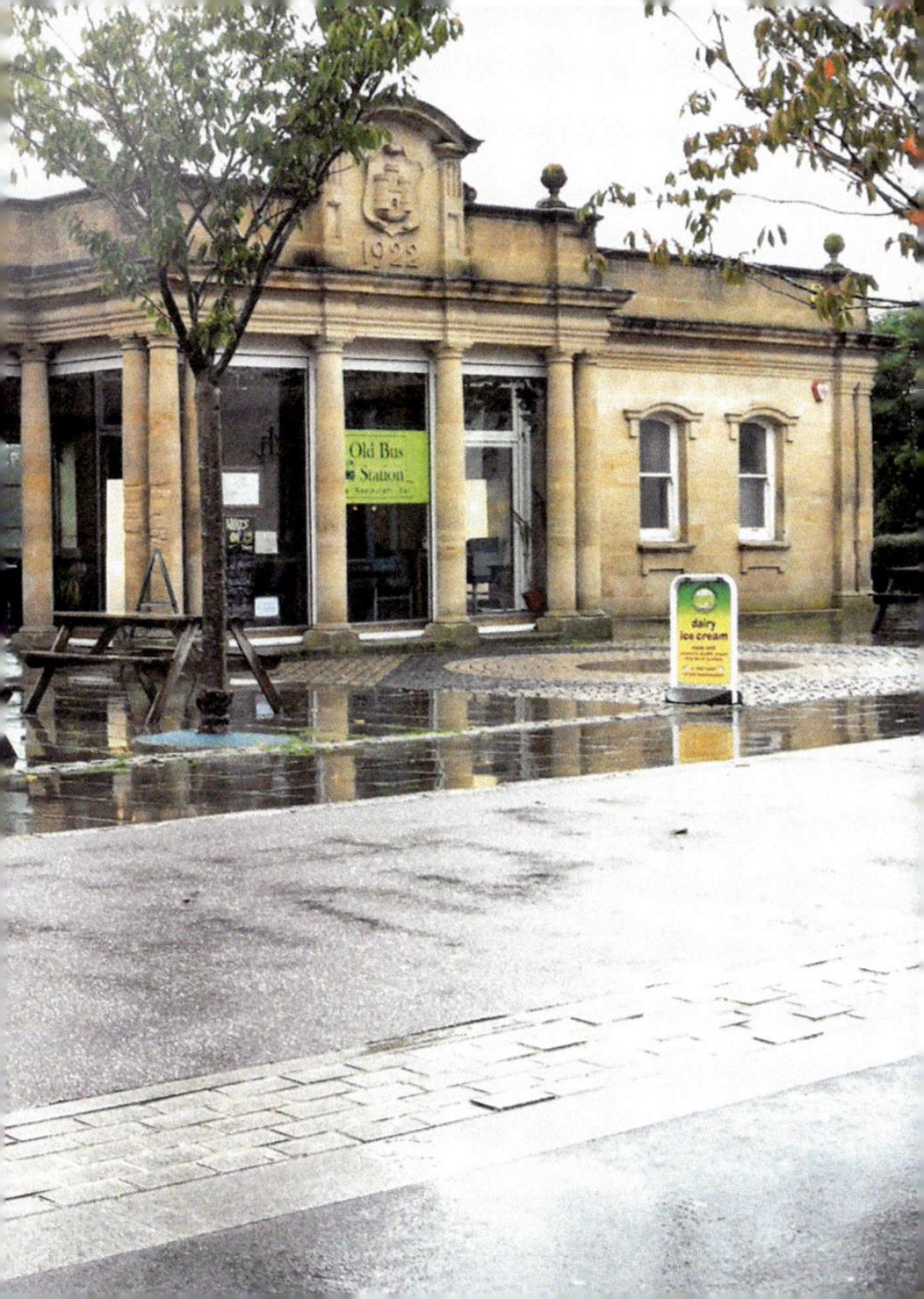

42. CONGREGATIONAL SCHOOL

Walking further to the end of The Strand, on the corner of Cross Street, you will see the Congregational School. The current building dates from 1894 and replaced an earlier version built only forty years previously. Both versions were designed by R. D. Gould and erected on the site of dilapidated buildings known as Rat's Castle. R. D. Gould was Borough Surveyor for fifty years and designed most of the Victorian buildings we see today in Barnstaple. The West Gate stood at this end of Cross Street and the arch had only been demolished in 1852.

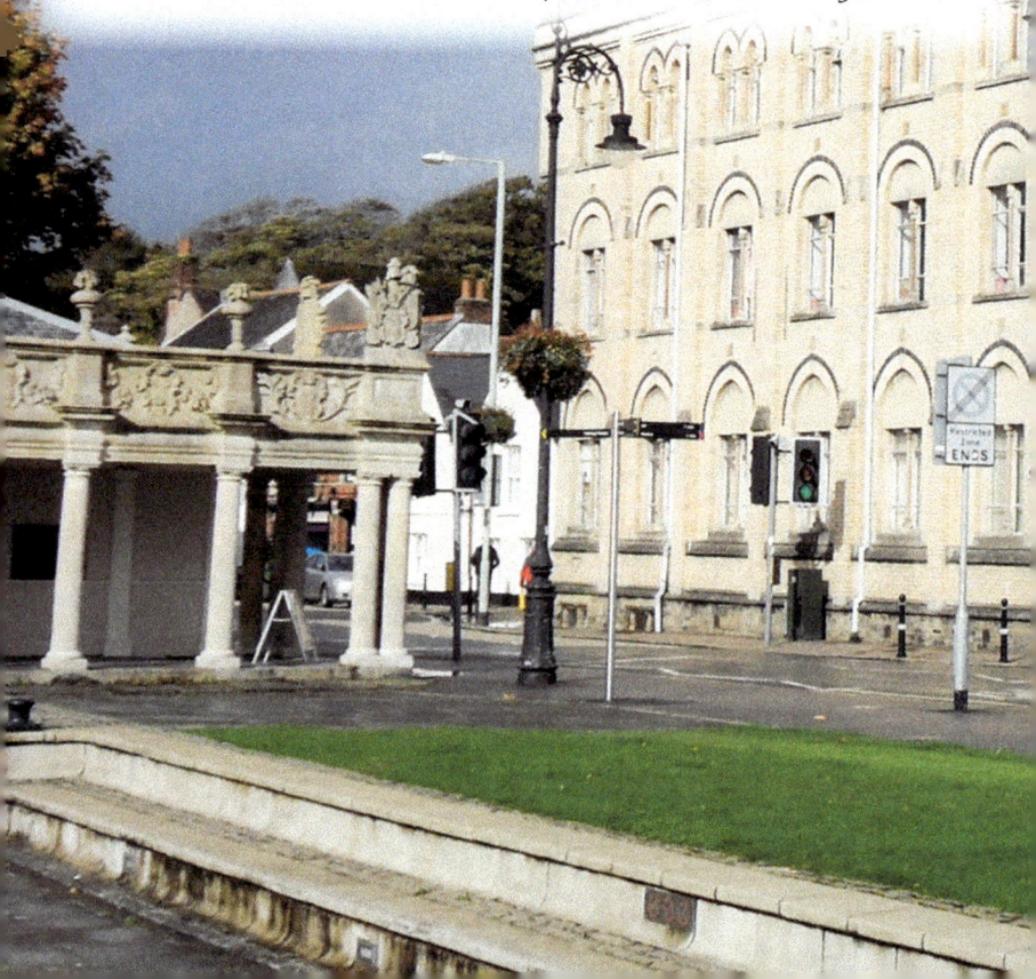

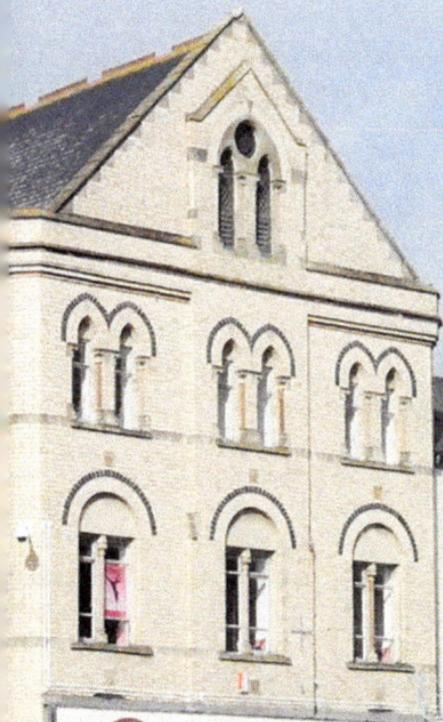

43. CROSS STREET I

At this point turn right into Cross Street. One of the oldest streets in Barnstaple, it leads from the High Street down to the river and the site of the Great Quay. It was originally known as Crock Street, probably as it was the site of the potters' market. In the sixteenth century several of the town's wealthy merchants had their houses along this street.

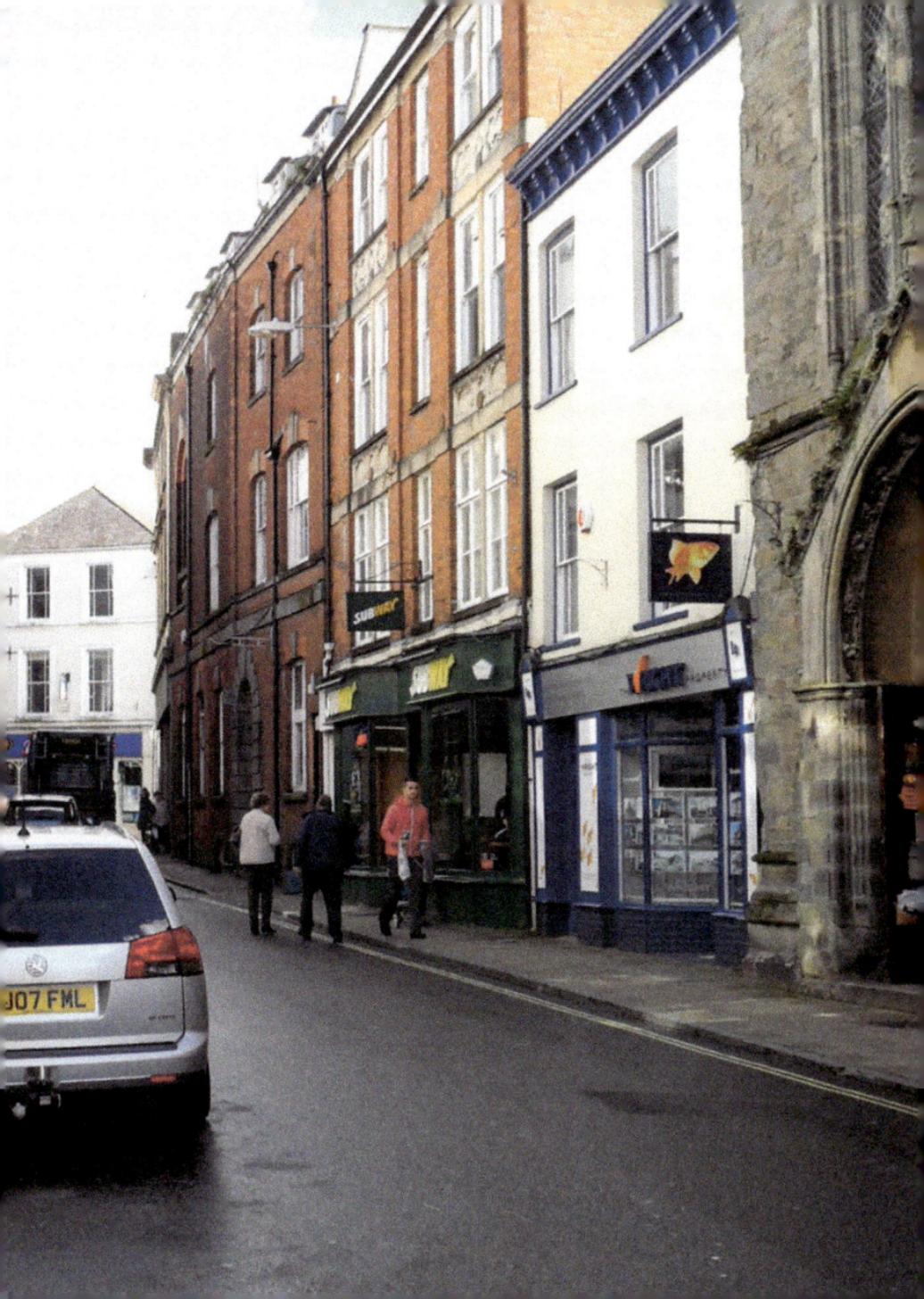

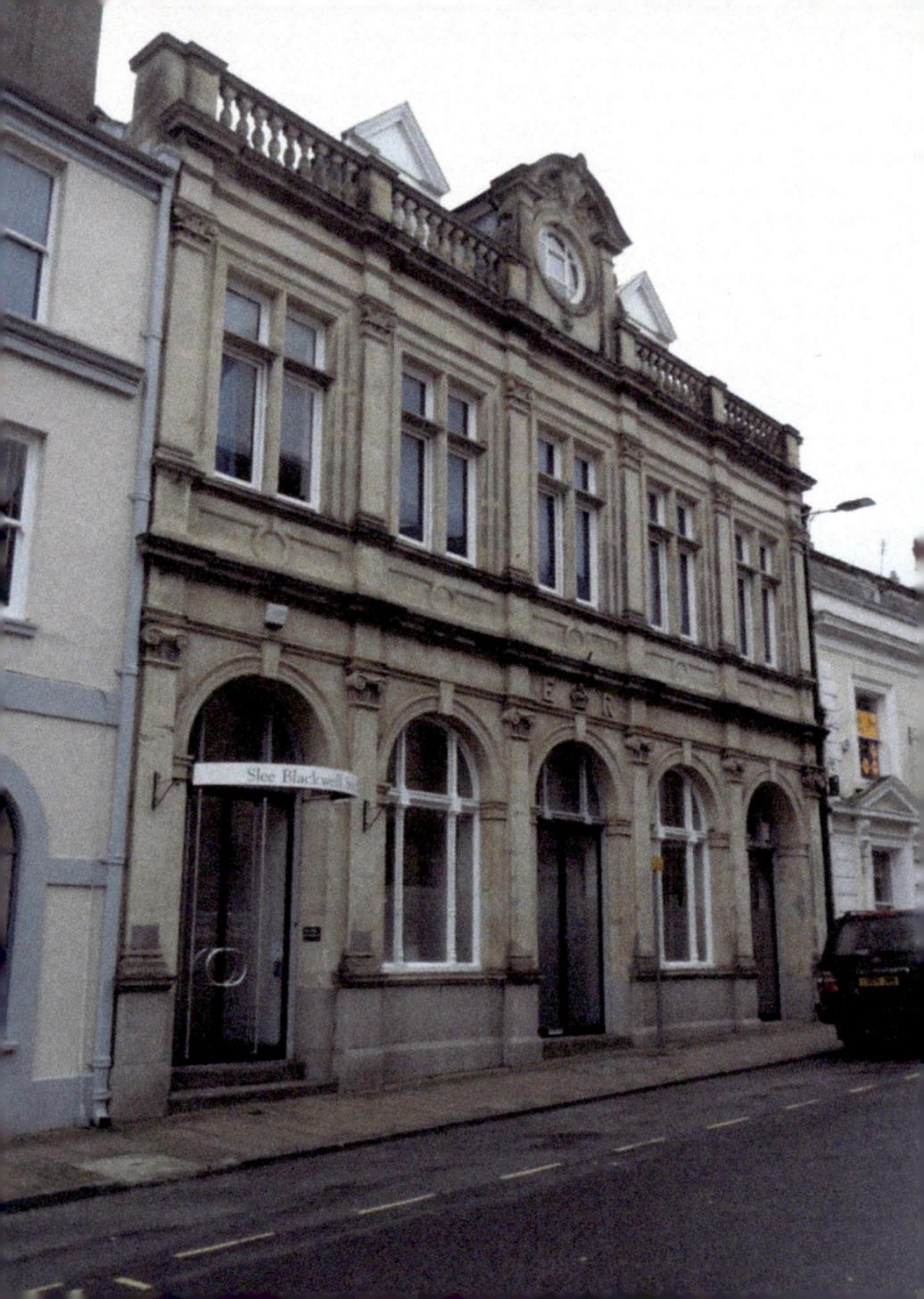

Slee Blackwell

44. CROSS STREET II

As you begin to walk up Cross Street, on your left you will see the old post office. Built in 1901, the 'ER' above the entrance refers to Edward VII, who had just succeeded his mother, Queen Victoria. It is built on the site of the grand Tudor mansion owned by wealthy Barnstaple merchant Pentecost Dodderidge. When the mansion was knocked down the beautiful carved oak fireplace was saved and is now on show in Barnstaple Guildhall.

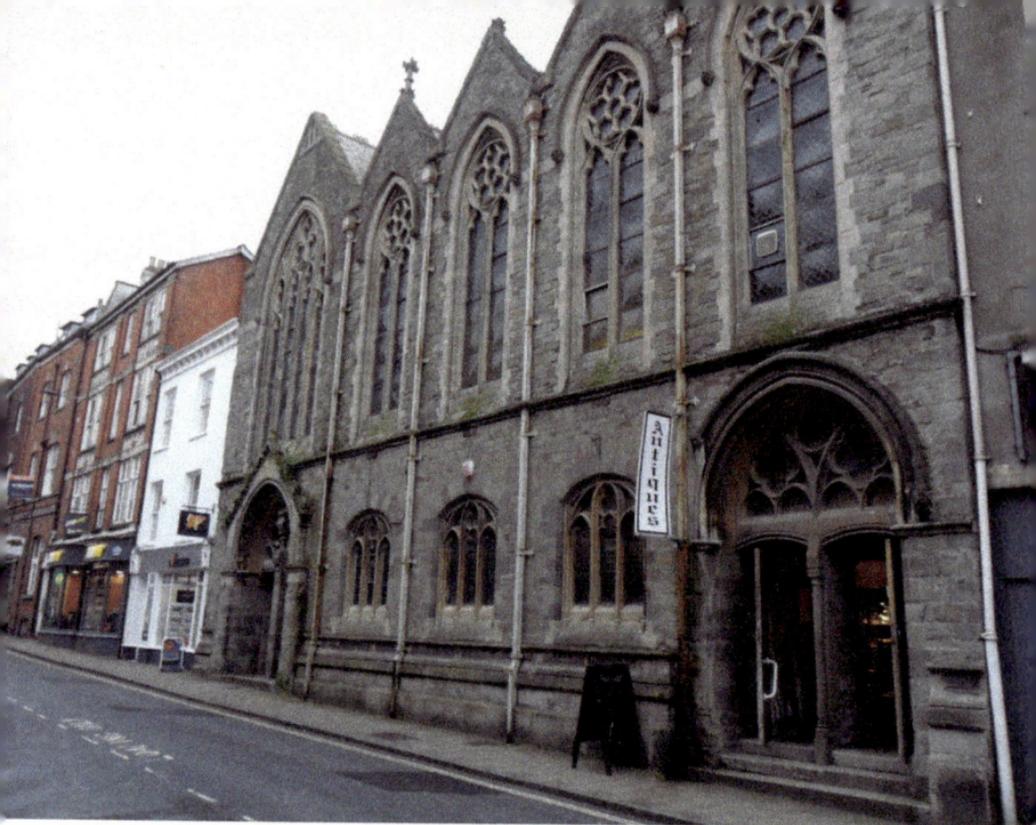

45. CONGREGATIONAL CHURCH

The final place of note on our tour of historic Barnstaple is the Congregational Church along Cross Street, built in 1870 and replacing an earlier one erected in 1705. Built in a style referred to as Middle Pointed, this building was designed by R. D. Gould and his son J. F. Gould, who worked with his father, but died prematurely in 1881. The previous church was considered too small and the new one could seat 700 people. It cost £2,000 to complete. Note the attractive carved angels above the door. The building is now used as an antiques centre.